WISE WOMEN

Virginia
— this book is to
a women that should
be on page #1.
Thanks for the laughs!
 Love,
 BROOKE

Virginia —
thank you for
listening to me & giving
me advise... you truly are
a wise women.
Cheers to a better
 year!
 ♡ YA BAiley

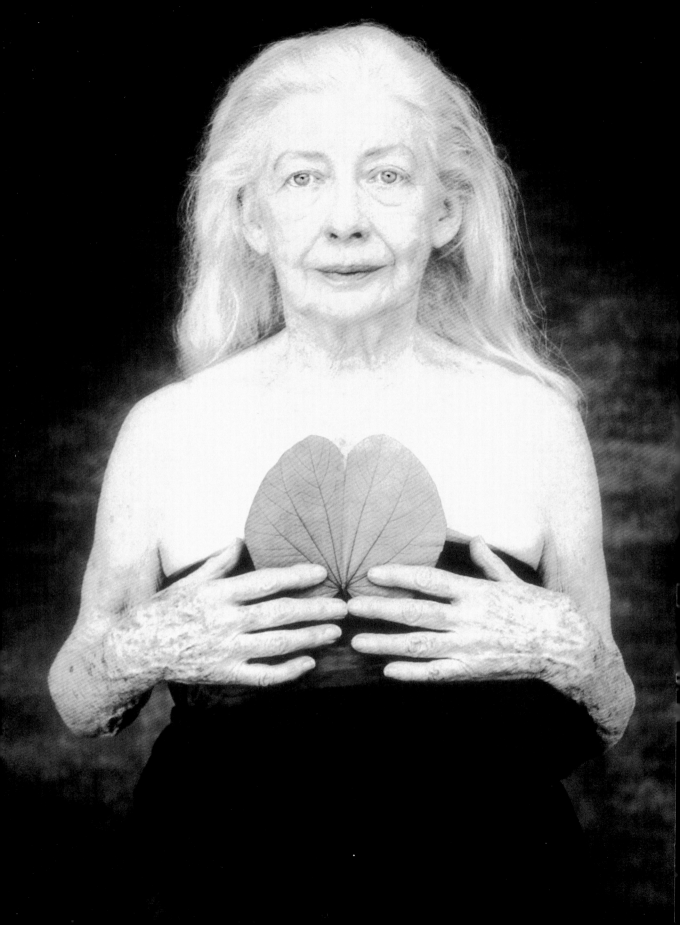

JOYCE TENNESON

WISE WOMEN

A Celebration of Their Insights, Courage, and Beauty

BULFINCH PRESS
NEW YORK BOSTON

Bulfinch Press

Time Warner Book Group
1271 Avenue of the Americas
New York, NY 10020
Visit our Web site at www.bulfinchpress.com

First Edition
Seventh Printing, 2005

Library of Congress Cataloging-in-Publication Data
Tenneson, Joyce.
Wise women : a celebration of their insights, courage, and beauty / [photographs by Joyce Tenneson]—1st ed.
p. cm.
ISBN 0-8212-2801-3 (hc) / ISBN 0-8212-2818-8 (pb)
1. Photography of women. 2. Aged women—Portraits. 3. Tenneson, Joyce– I. Title
TR681.W6 T485 2002
779'.24'0846—dc21

2001052812

Designed by Michael Goesele
Tritone separations by Martin Senn

Printed and bound by Amilcare Pizzi, Milan, Italy

I dedicate this book to all the extraordinary women in these pages who entrusted me with their faces, their bodies, their thoughts. I admire their courage, their wit, their strength, and their beauty. They are the true revealers of the inner power of wise women in our time.

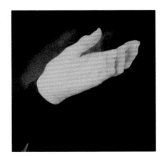

INTRODUCTION

Many of us fear growing older. We assume that advanced age is a time of degener-
ation, when physical and mental qualities are in sharp decline. We fail to recognize
the energy, vitality, wisdom, and deep beauty possible in these later years. My hope
is that this book will help to dispel this negative attitude by portraying women whom
age has enhanced, not hindered, whose lives can serve as positive role models for all
of us.

Wise Women is my seventh book of photographs and by far the most con-
suming project of my career. I photographed and interviewed nearly three hundred
women and traveled from Maine to California in an effort to discover what the
third phase of life felt and looked like.

This book took enormous physical and organizational effort from everyone
concerned. It involved seemingly unending travel, scheduling and rescheduling with
busy celebrities, and constant coordination with the vast network of colleagues and
friends who helped ferret out the extraordinary women from all walks of life who
fill these pages. At a certain point, I was swept up by a hidden source of energy and
fascination that was shared by everyone who became involved with the project. It
was as if I had tapped a hidden well—a previously undiscovered source that became
increasingly powerful as the faces, stories, and insights began to accumulate. As
time went on, the book took on a life of its own. I felt I had been given a gift as well
as a responsibility.

During our portrait sessions, these women shared not only their outer
appearances but, more important, their inner lives—the heartaches as well as the
triumphs. We talked about our families and the longings of our hearts. As we
spoke, we discovered that the journeys we had taken toward our deeper selves,
toward acceptance, love, and hopefully compassion for the frailties of the universe,

were basically the same. I came away from each new encounter exhilarated by what I had seen and learned, and with an urgent desire to share these stories.

All the portrait sessions were memorable in their own way. I photographed Julie Harris (pp. 128, 129) at her last performance of *The Belle of Amherst*, the renowned Emily Dickinson show she has done for audiences around the world for twenty-five years. As she walked off the stage she seemed completely imbued with Dickinson's spirit. I felt gifted to witness and capture the moment. I met Krista (p. 122) at a wedding and immediately asked if I could photograph her. She agreed to the photo session with one stipulation: that I photograph her partially nude. She wanted to show people that a mastectomy "doesn't look so bad" and that she still feels beautiful. Odetta arrived and immediately charmed everyone at my studio by playing her guitar and singing for us (p. 55). I saw Sister Elise and Sister Mary Christabel on the sidewalk of 120th Street and asked them to be part of the project (p. 63). Ann Richards (p. 92) walked to my studio from her hotel in Times Square and gave me notes from a workshop she had taken at age sixty-five that had helped her evaluate her goals and reinvent herself after being governor of Texas. She said she had never felt better. I waited six months to get a portrait session with Coretta Scott King (pp. 136, 137). Dame Judi Dench and Patricia Neal (pp. 116, 117 & 33) met for the first time at my studio and expressed a mutual and touching admiration for each other's work.

I took the train to Washington, D.C., one spring morning to photograph Sandra Day O'Connor at the Supreme Court (p. 88). I was charmed by her intelligence and passion for her grandchildren. I also went to Woodstock, N.Y., to meet with a group of retired women in the creative arts. They were all still working, helping write grants for arts funding, painting, playing music, or mentoring younger artists. I

found Lola (p. 22) and her granddaughter in my apartment elevator. Their grace and spirit continue to enrich my life. Later, I took twenty of my students in Santa Fe to meet Angelita and Connie (p. 126) while I photographed them in the backyard of their pueblo. Their sense of connection with the earth and the fact that Connie has found new powers as a healer in the past few years were felt by all of us.

Many of these women had not been photographed in many years. Deirdre (frontispiece) was startled to see her current image. She said she saw something she hadn't seen for a long time—her inner self. Polly (p. 51), formerly a journalist for the *New York Post,* still lives by herself at ninety-eight, drives, and exercises every morning for an hour. She feels she has led many lives and is amused to find she has become a role model for others in their seventies and eighties.

While I was photographing my subjects, we talked. I was hoping to capture a brief thought or statement, unique to each of them, that would be a counterpoint to or illuminate their portrait. Each woman I met had something original or insightful to offer. I was struck by the fact that those who had led quieter, more anonymous lives were as perceptive as the famous and powerful. The experience of aging seems to be encouragingly evenhanded in its distribution of wisdom.

Almost without exception, these women presented themselves in a very direct, authentic manner. They spoke of a new sense of personal freedom and their relief at letting go of others' expectations and society's conventional definition of female beauty. As they had transformed themselves and their priorities, many felt compelled to make a difference in the world and give back some of the joys and insights they had received. Others felt a call and longing for a deeper inner life and spiritual path. Many said that their life experiences had made them more compassionate and had given them deeper wisdom or perception they wanted to share.

Our society has repeatedly confronted and managed to change many negative stereotypes of women; aging is our final frontier. The fastest-growing segment of our population is over sixty-five. The lack of respect for and understanding of America's older population requires major reexamination. We need to forge a new image of older women, one more in keeping with ancient times, when they were revered for their special abilities and wisdom.

As the baby boom generation ages, our society will change dramatically. By 2010, one in four people in the United States will be over sixty-five. If our elders are able to channel their unique powers into social, political, and humanitarian action, they could potentially change the values of the world. By altering the negative stereotypes of aging, both men and women can be liberated from the myth that elders are useless or "over the hill." It is clear that our society is at a turning point in many ways. The pendulum has swung from championing materialistic forces of power and success to a collective yearning for connection. The ancient female values of compassion and relatedness could help usher in a new time, one with a new respect for the value of relationships.

When I began this project, I saw it as a culmination of my own journey as an artist interested in investigating, discovering, and recording the female life cycle. It became much more. It challenged me on every front: intellectually, emotionally, and physically. It made me question who I am and who we all may become. It caused me to ruminate on what a face or a portrait can reveal.

The photographer Henri Cartier-Bresson once said, "At a certain point, one gets the face one deserves." I believe this is true. My lifework has been studying faces, trying to make portraits that are penetrating and direct. I often feel like a spiritual midwife who facilitates an intimate connection between subject, photographer,

and viewer. I have also wanted to explore and bring the fruits of that journey into my life, my relationships, and my work.

A portrait can sometimes obscure the inner life of an individual, but we all have an inner face that, although often hidden, can be felt. This is particularly true as we age. While photographing these women in their sixties, seventies, eighties, and nineties, I realized I was often looking into the secret center of their being. Most were no longer interested in hiding behind a mask. Those with great love in their hearts showed it in their eyes, those filled with bitterness or selfishness reflected coldness, those with mischievous spirits still summoned that playful vitality, and those with an abundance of spirit revealed that warmth and tranquillity.

A true portrait can never hide the inner life of its subject. It is interesting that in our culture we hide and cover the body, yet our faces are naked. Through a person's face we can potentially see everything—the history and depth of a person's life as well as the evidence of a primal universal presence. It is to penetrating that private world, to capturing these elusive but magic moments of revelation, that I have dedicated my life and talent.

I hope these photographs provide surprises as well as moments of recognition. I hope they will foster a new respect and understanding that could inspire us all to look at aging in a different way. I've learned so much from these wise women; they have given me more than I can say. Through their willingness to share, I feel I have touched upon the true meaning of life. I always photograph in the hope that the divine will show up and bless the work. I continue to do so.

Joyce Tenneson

WISE WOMEN

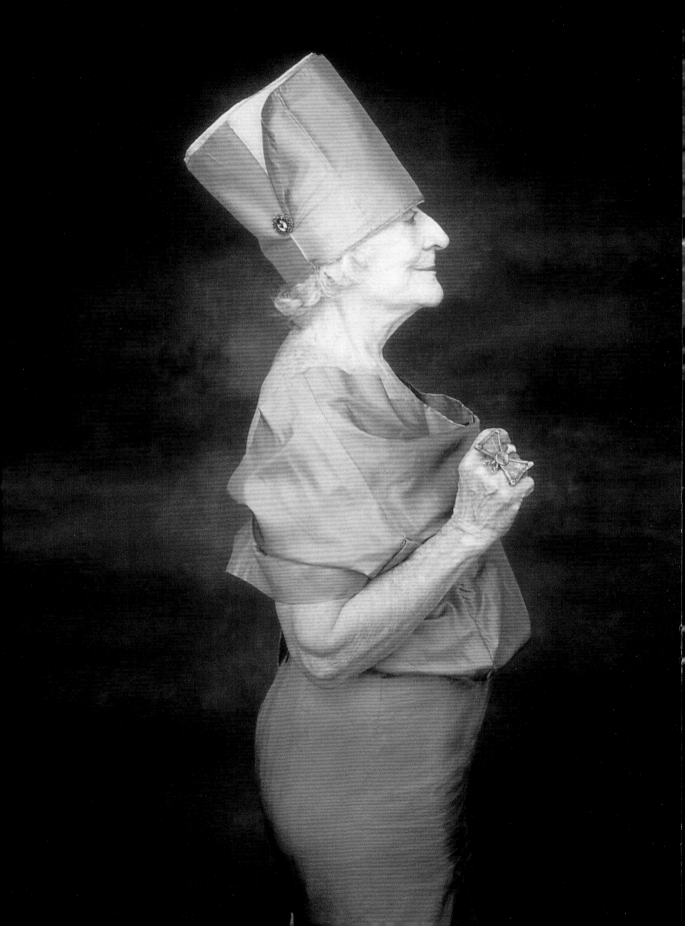

I used to dance a lot,

but unfortunately, all my partners are dead.

Now I travel to remote villages around the world

where women weave their own cloth.

I design all my clothes

and try to keep the integrity of the cloth.

I like hats.

This one makes me feel like I'm a mythic priest

who brings joy and love to the people around her.

Zelda Kaplan, 85

People often stop me now

 and tell me I'm beautiful.

I never had this happen when I was younger.

 So for me aging has,

 at least on the surface,

made others more interested in me and who I am.

Betty Silverstein

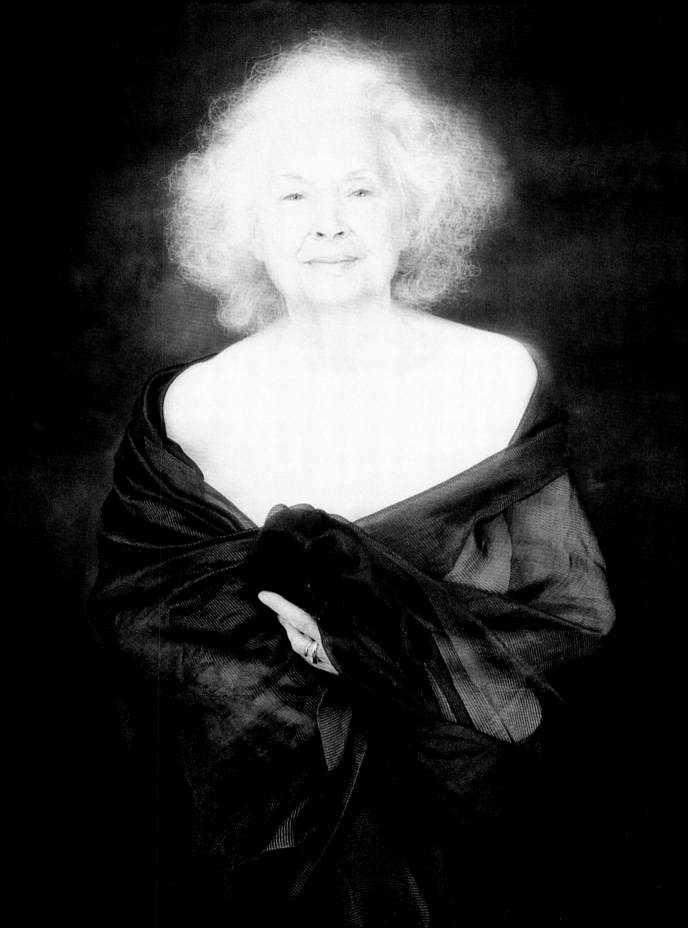

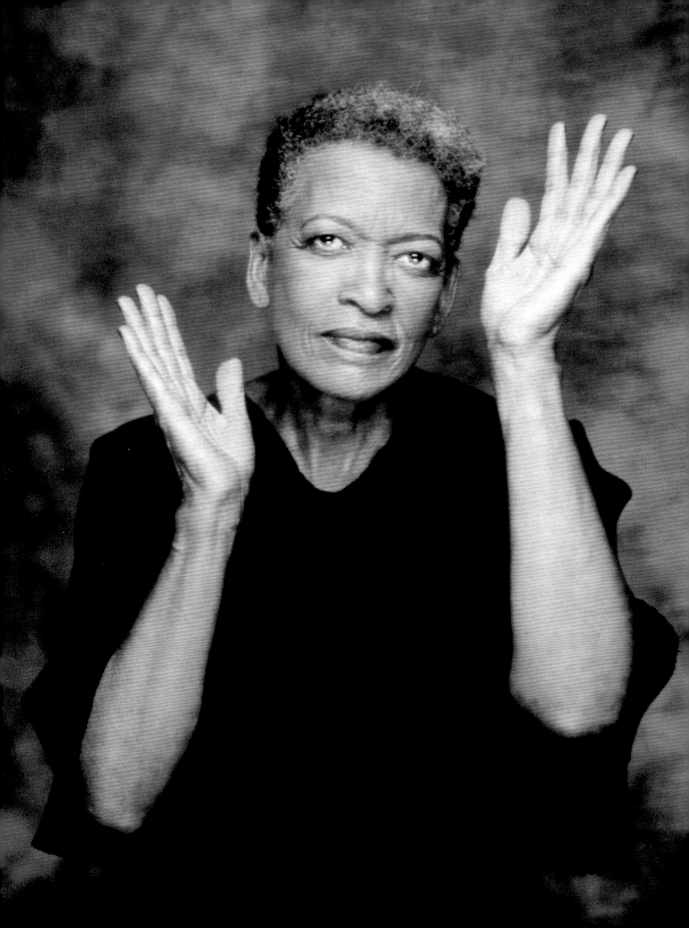

I was the first black female president

in one hundred and seven years at Spelman College.

 I'm proud of the sisterhood we have created—

it is about connectedness.

 We create a new family for our women

by treating one another

as if we were from the same womb.

Dr. Johnnetta Cole, 65

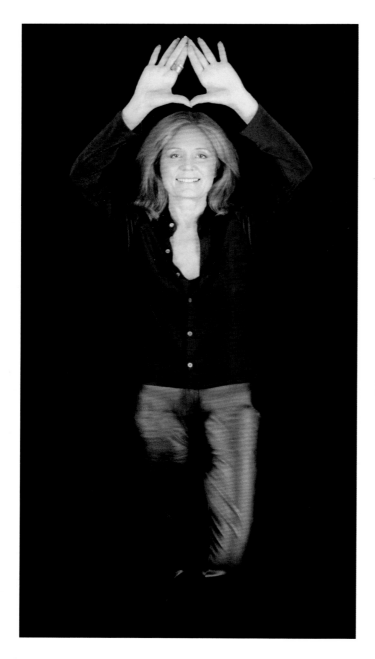

Many of us

are living out the unlived

lives of our mothers,

because they were

not able to become

the unique people they were

born to be . . .

Gloria Steinem, 67

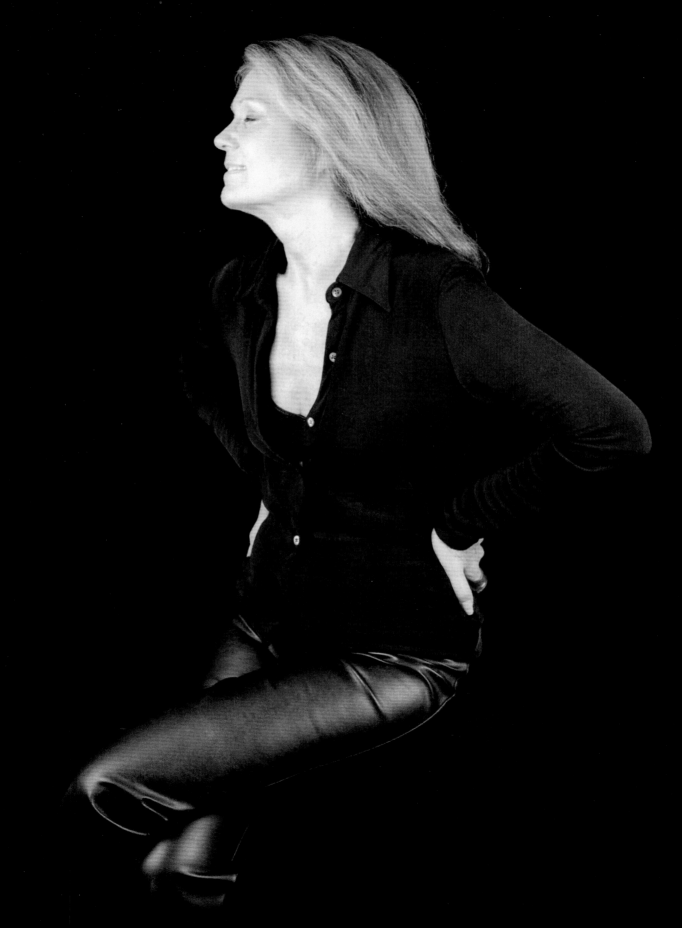

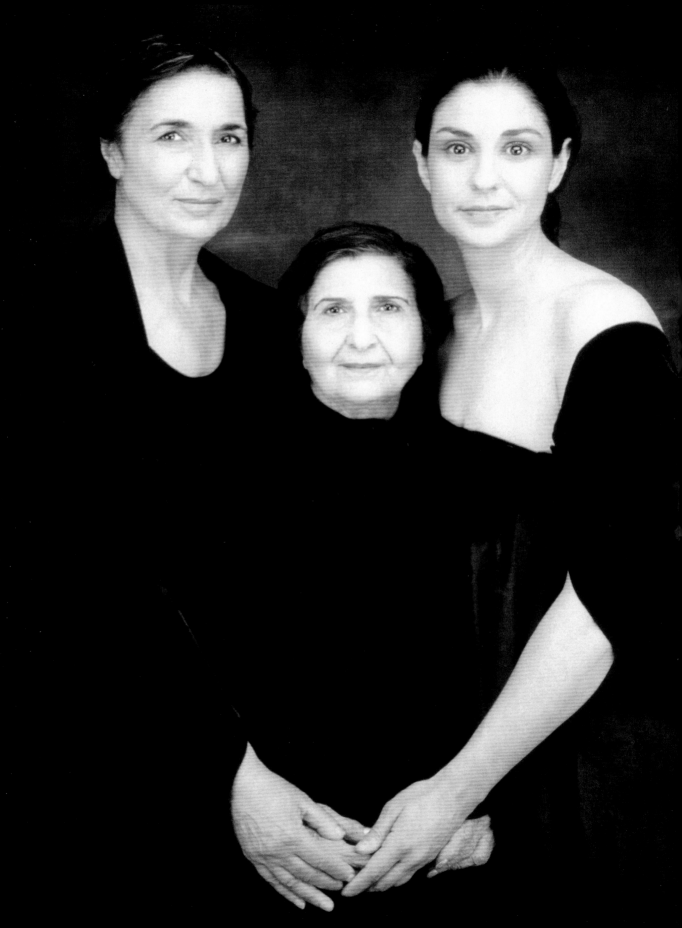

I am so proud of my family.

I got married at seventeen,

and the world was very different back then.

My granddaughter Natalie suggested we do this portrait

because these are the most significant people in my life.

The portrait celebrates

a way of staying connected.

LEFT: Hannah Cohen, 60
CENTER: Sophie Saleiman, 80
RIGHT: Natalie Cohen, 33

Lola Santos, 76, and granddaughter Alex

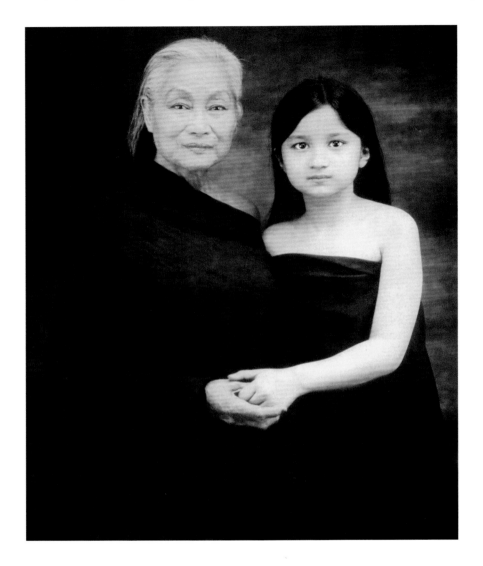

Make use of all your faculties

 while you are going toward your golden years,

because you want to be of service.

 To give of yourself, to love—

this is why we are on earth.

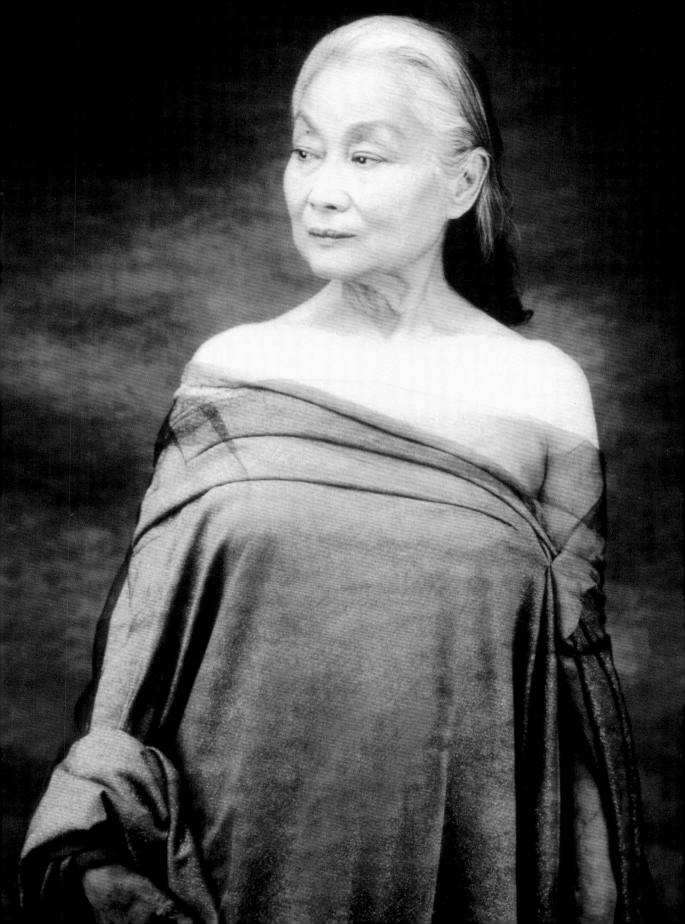

Maezie Murphy, 83

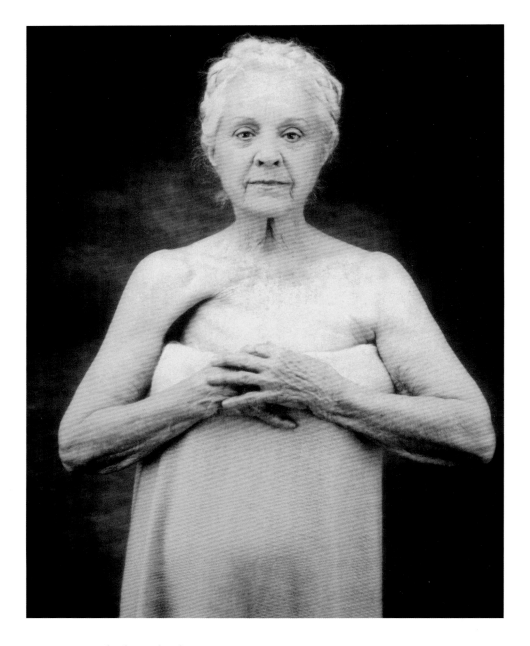

I had a radical mastectomy years ago

and I like to tell people, "Yes, I had cancer and no, I didn't die."

If you have faith in God,

you always have someone you can count on.

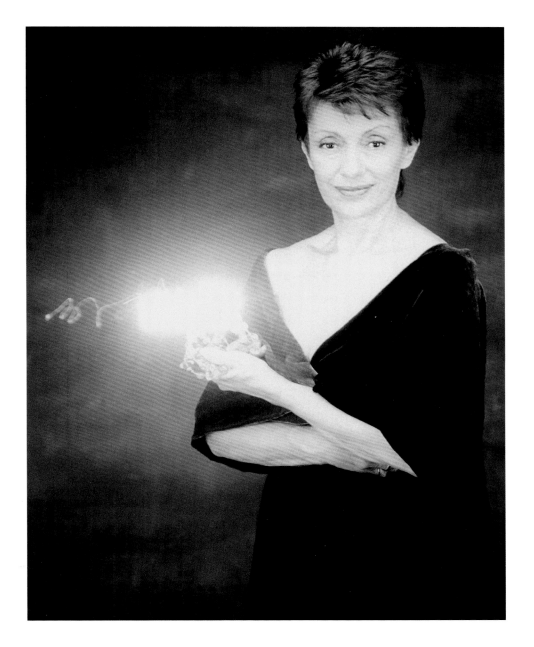

I've always believed

that whatever you are when you are young,

as you age,

you become more so.

Each day I practice chi quong,

an Asian discipline that promotes energy

through proper breathing.

The shape of my hands in this photograph

re-creates the symbol of energy

going through the fingers.

Five years ago I had open-heart surgery:

now each day I feel I am here for a purpose,

not just as director of my own gallery

but on a personal level,

by trying to bring cultural stimulation

and a sense of beauty to all those

who cross my path.

Fay Gold, 67

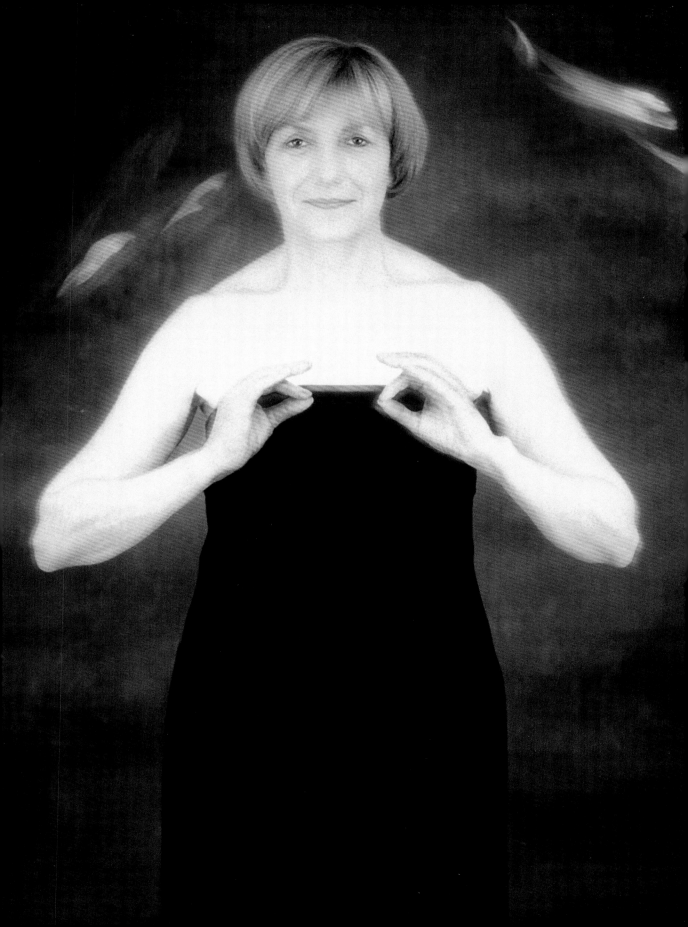

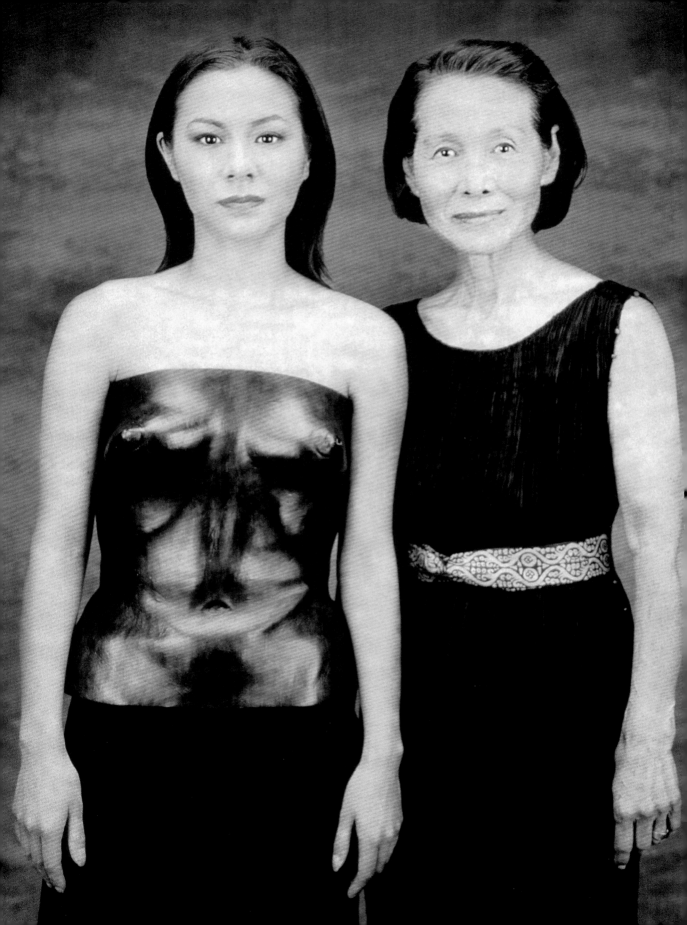

I don't think of myself as being old.

When I'm with my granddaughter, China,

I feel the same age. I was born in Japan.

I was brought up in a very old-fashioned way.

There is not the same attention to etiquette anymore.

I love China's Yves Saint Laurent outfit.

It's so different from my Fortuny dress, which is fifty years old.

They are both beautiful in their own right.

LEFT: China Chow
RIGHT: Mona Miwako Lutz, 78

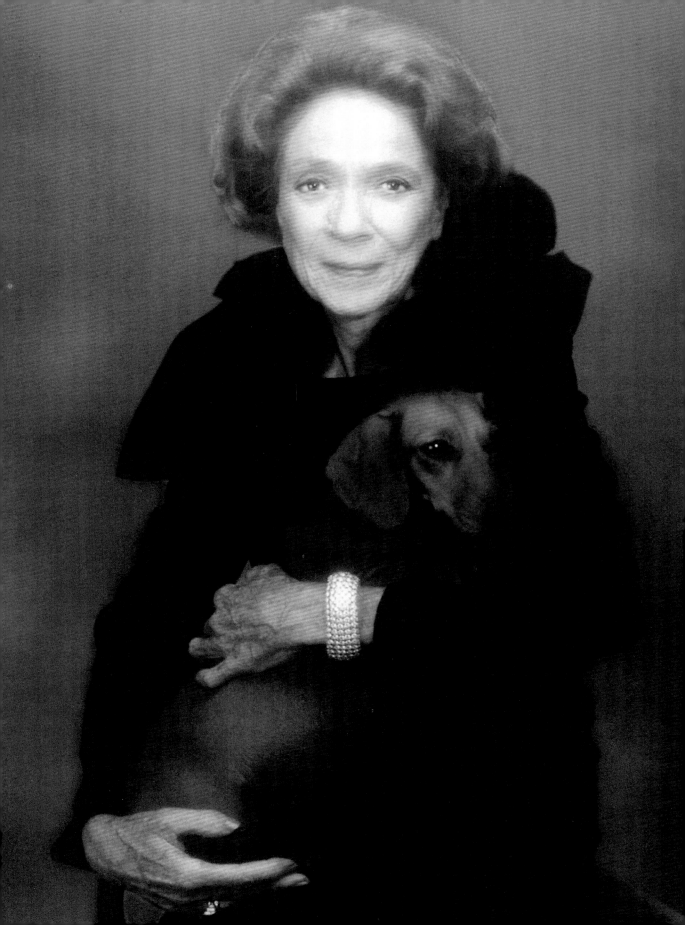

I grow more intense as I age,

and I am more passionate

about the projects I believe in.

I still enjoy getting dressed elegantly in the evening

and making an "entrance" at a party.

Brooke Astor, 98

I always wear my gold Oscar necklace.

I won it in April

and nine months later I had a massive stroke.

I was at the peak of my powers.

I was angry, but stubbornness helped me get through.

Patricia Neal, 75

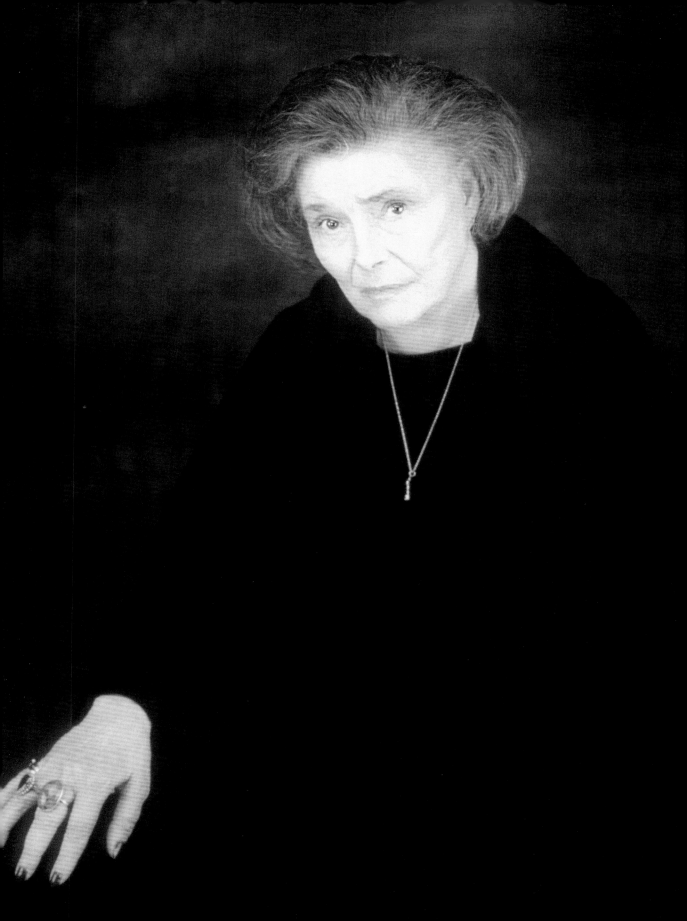

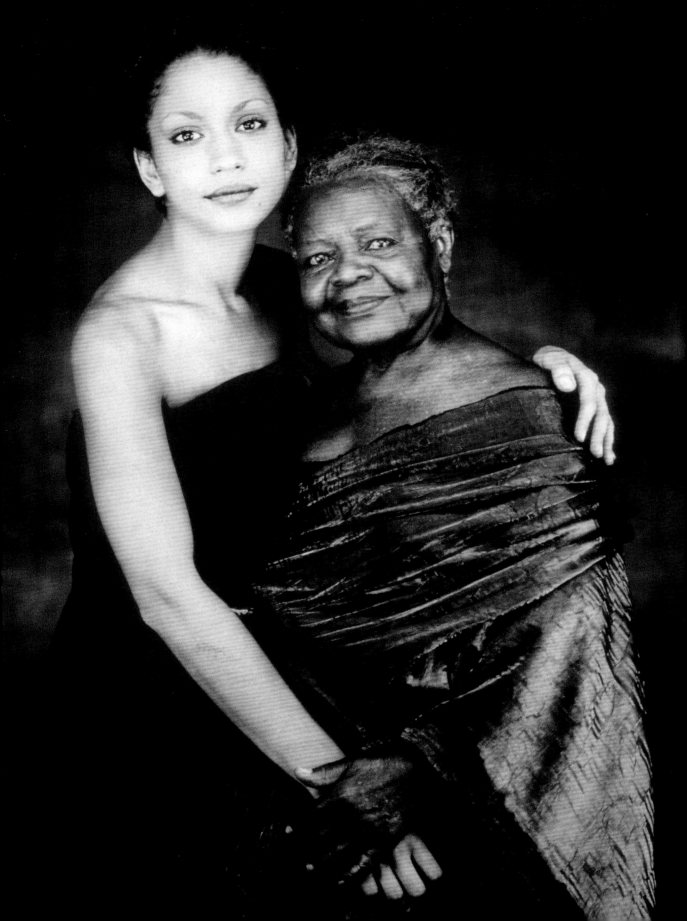

Everyone calls me "Miss Birdie."

My mother said I looked like a bird when I was born,

so that's what she named me.

I walk four miles a day

and drink half a gallon of water—that keeps me healthy.

I have no sympathy for people

who abuse their health.

Birdie M. Hale, 88, and friend

Many of my friends

 are experiencing the loss of their beloved pets.

I have watched them mourn these deaths

 and realize it is not the pet they miss,

 but the loss of their unconditional love.

That's what really hurts.

Dina Paisner

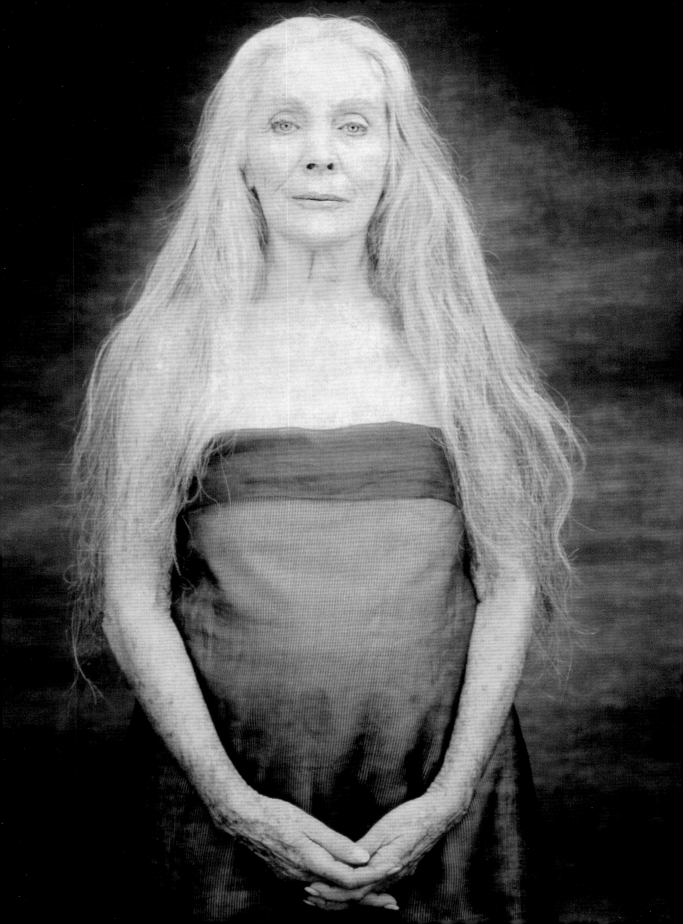

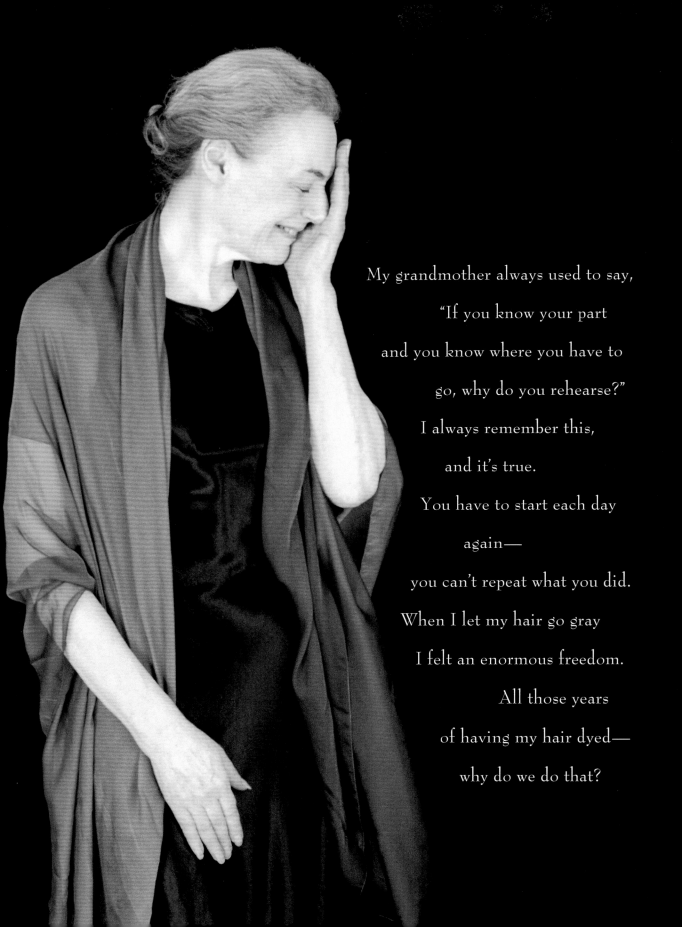

My grandmother always used to say,
"If you know your part
and you know where you have to
go, why do you rehearse?"
I always remember this,
and it's true.
You have to start each day
again—
you can't repeat what you did.
When I let my hair go gray
I felt an enormous freedom.
All those years
of having my hair dyed—
why do we do that?

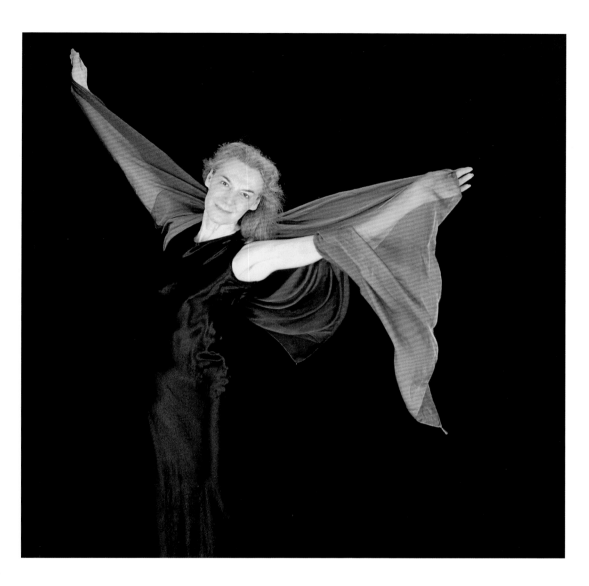

Marian Seldes, 73

Being in opera is my life.

I've played Madame Butterfly more

times than almost anyone else alive,

and the story continues to absorb me.

Tragic, poignant love will always

fascinate and touch people.

Licia Albanese, 88

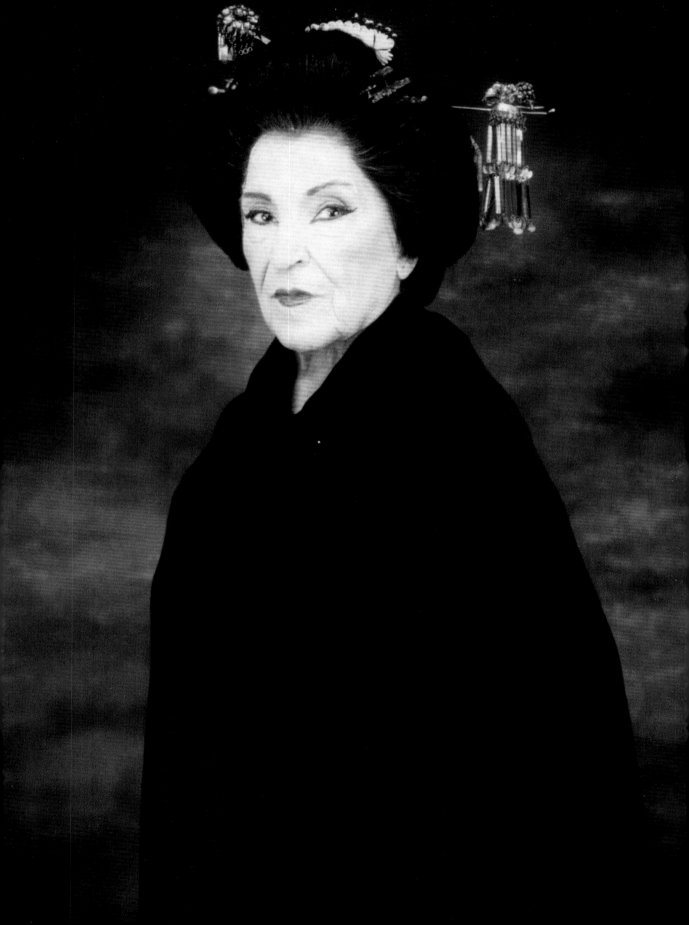

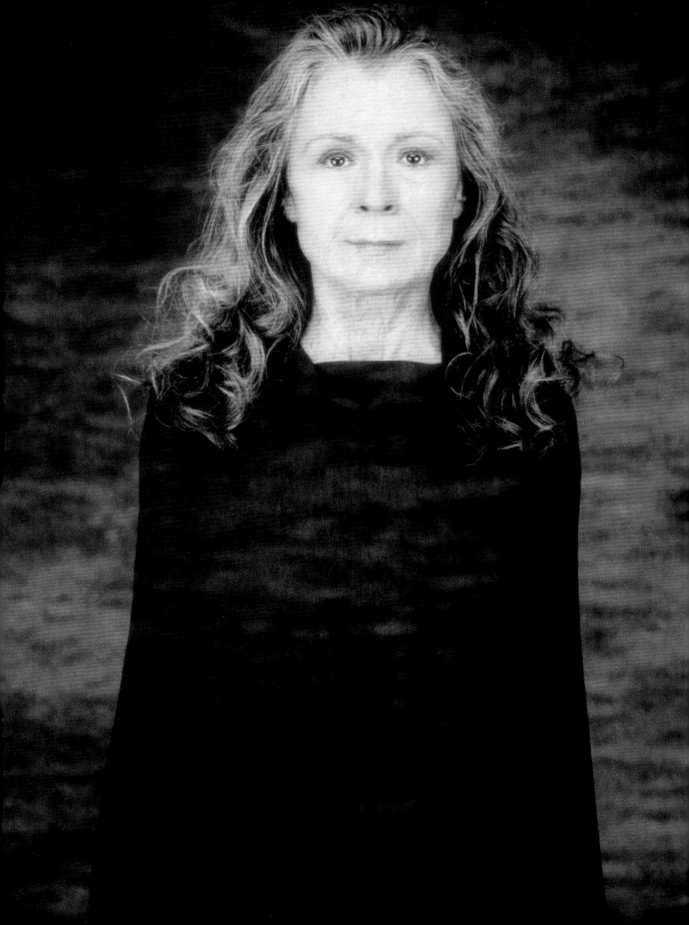

I think it's cool being older—

I still get hit on.

People are always telling me how beautiful I am now.

It's like they are almost incredulous because the old stereotype

is that we shouldn't get more beautiful with age.

I have respect for the body

and live in harmony with nature;

that's where the beauty comes from.

Marilyn Alex, 70

I've lived in city housing

for the past sixteen years.

I was an only child and never married.

I have no family now.

Without love we are nothing.

Gloria Larsen, 75

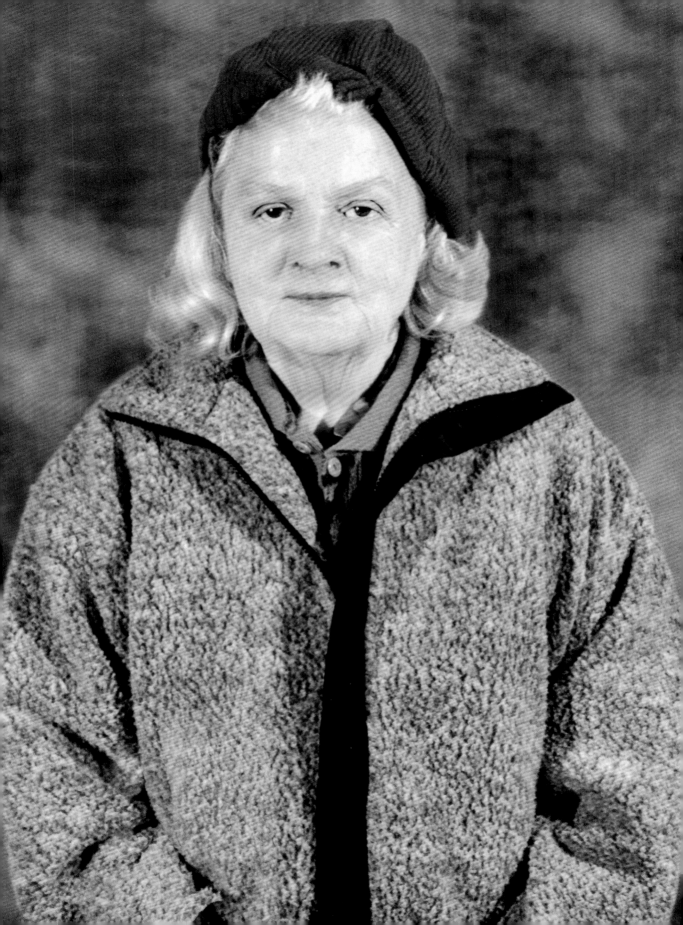

Helen Gurley Brown, 79

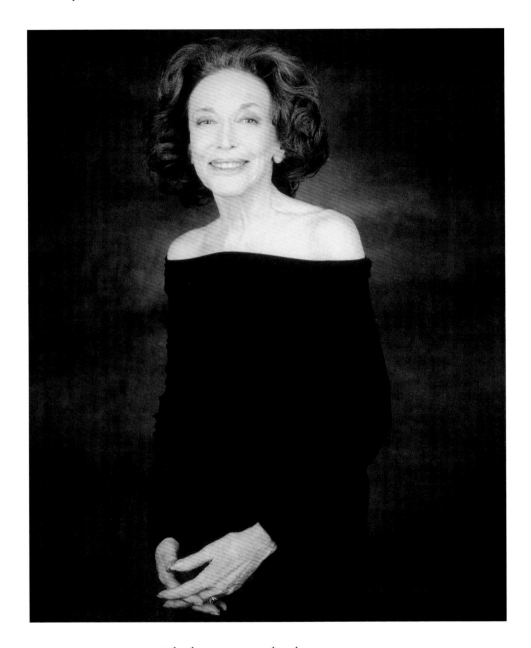

The happiest people I know

are not those who are the most beautiful, rich, or famous.

The happiest people I see are simply those who

stay cheerful and try to cheer up others

while getting through their own bad stuff.

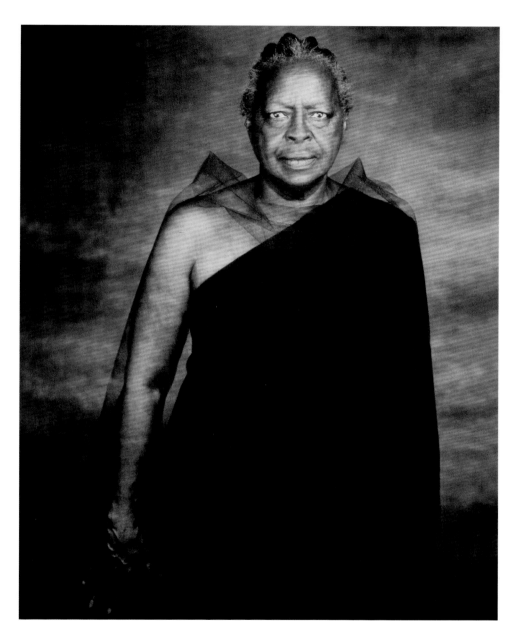

I'm working on

a self-help book for seniors

I'd eventually like to publish.

Seniors can become dependent.

I have no family here so I need to manage everything myself.

47

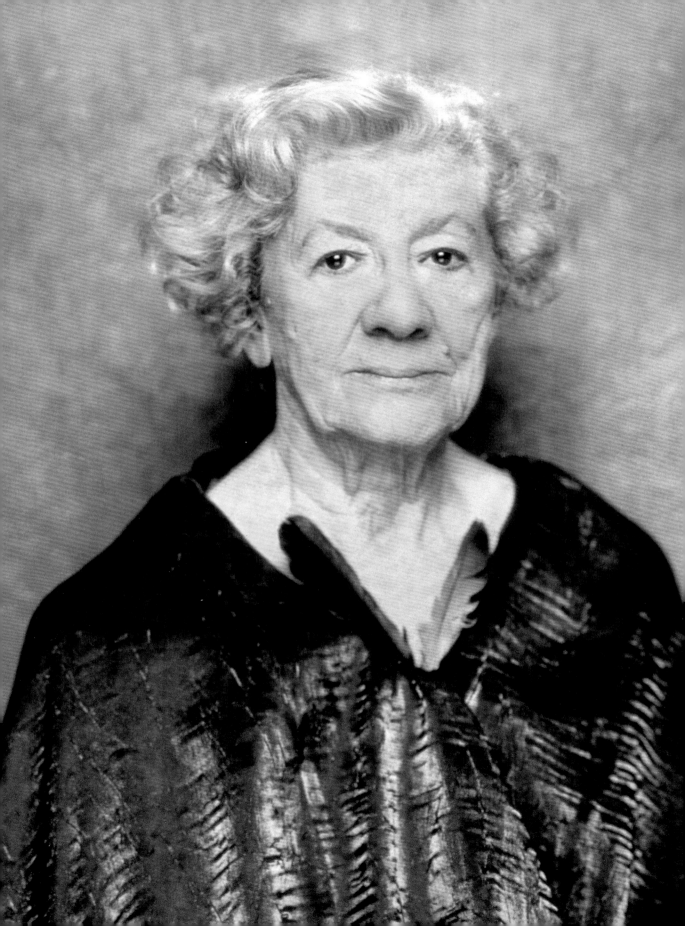

I'm a bit envious

 of the younger generation.

They have so much freedom compared to us.

 I got married the day I graduated!

A lot of my friends are passing away now.

 The rest of us are worried

 about outliving our pensions and assets—

we don't want to be a burden to our families.

 Now I live alone with my cat.

 I'm always collecting feathers.

I use them to play with him—

 we're good for each other.

Sadie Simms Allen, 81

I still don't dye my hair.

My advice is follow your conscience.

I've had several lives.

I'm not the same person I was

at twenty, forty, or even sixty.

Now I'm a role model

for women in their seventies and eighties!

When you're this old you can reconsider your whole life.

You can relive your life and

understand it with a pleasure and perception

not available when you first experienced it.

People are extremely nice to me now,

because I am no longer a threat to them.

Polly Kline, 97

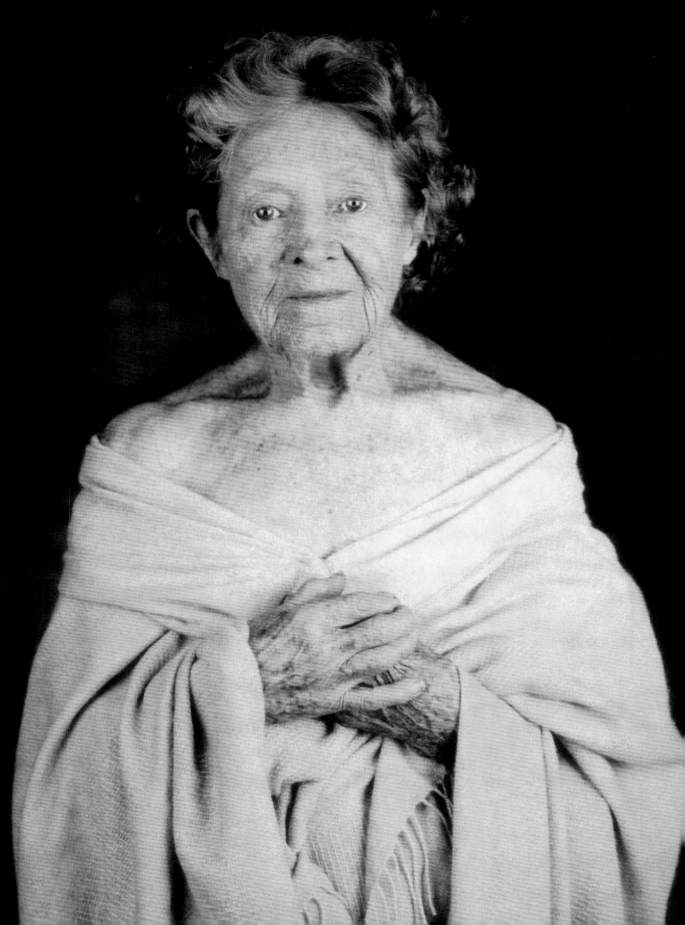

Elaine Alexander

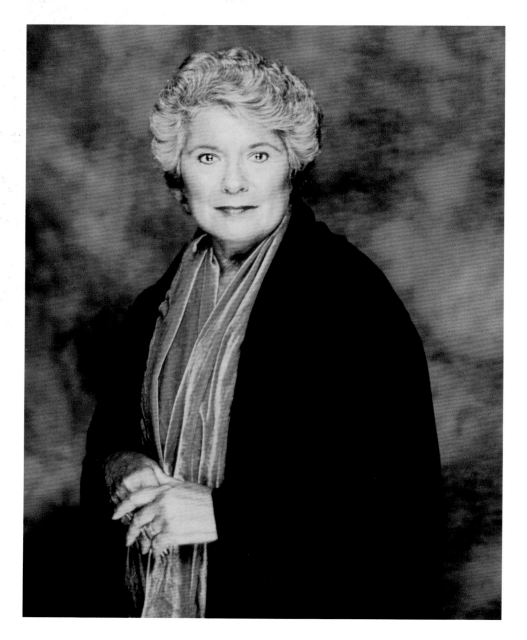

The sense of spirituality that seems

to increase as you age is not necessarily religious.

As I watch my eight grandchildren grow

and actually be there, existing and full of life,

I realize that the Holocaust didn't work.

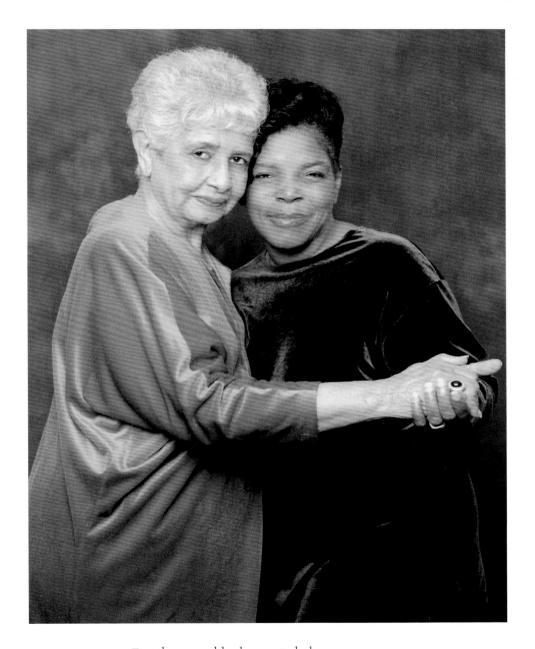

People are suddenly worried about

foreign cultures in America. If you are going to intern

them, like they did the Japanese, you may as well

take down the Statue of Liberty.

The beads on my forehead are symbols

of my third eye—

the eye of vision.

All of my schooling has been through music.

It was through folk music

that my spine was straightened.

I cut my hair and let it be natural—nappy.

I let my own personality out.

Thinking for yourself

is something we must bring to education.

We women need to pass that belief on to younger generations!

Odetta, 69

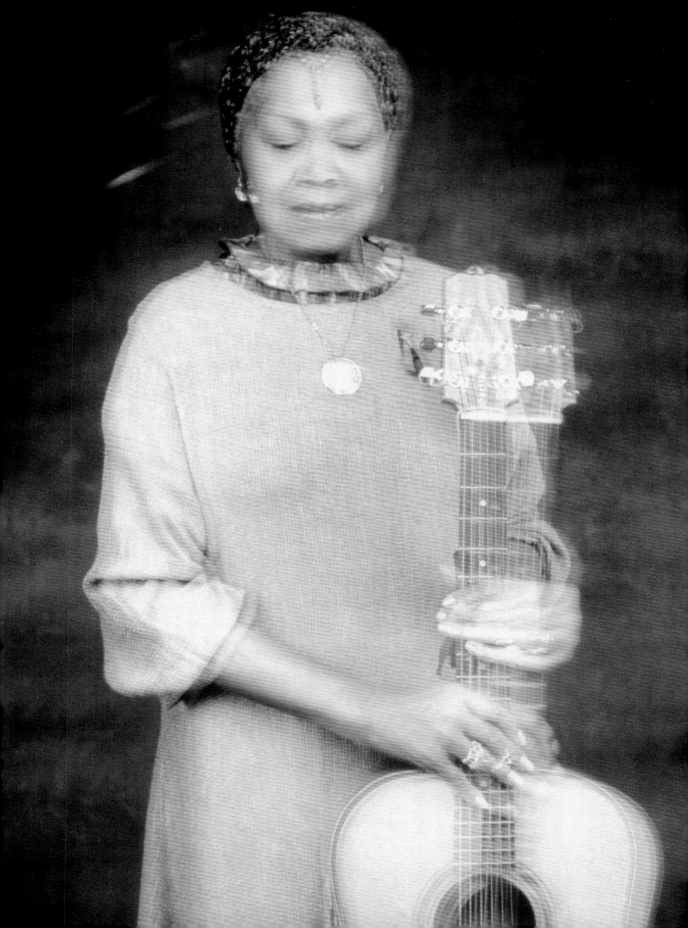

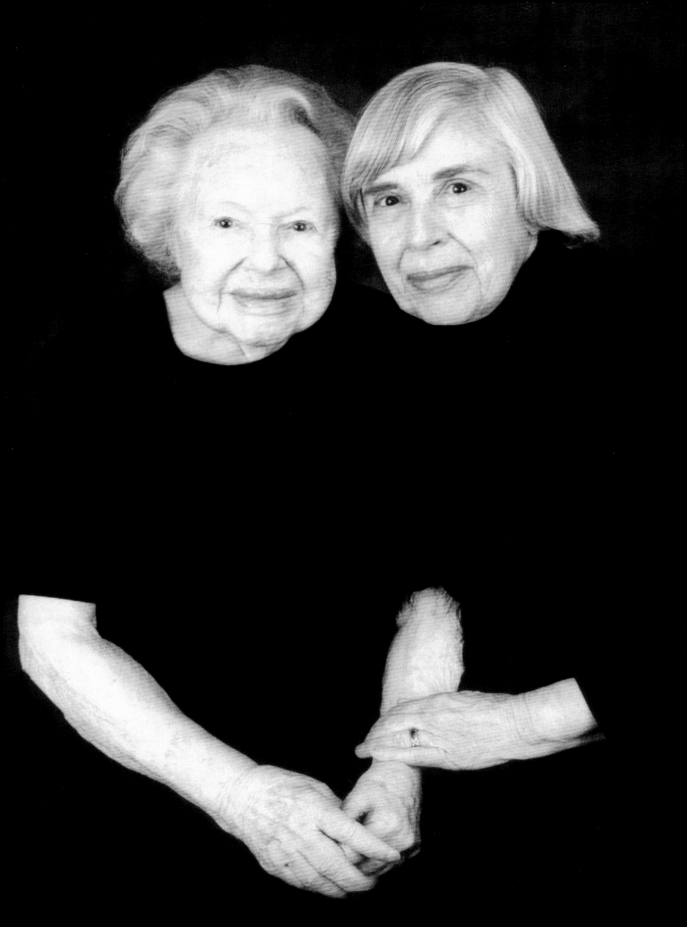

I just got married again.

I answered an ad in the *New York Review of Books*.

That's how I met Larry.

I am his sexual fantasy.

We have a wonderful life together,

but we kept our separate apartments.

We have more freedom that way,

and of course it's romantic as well.

This is my aunt, Edith Turner. I took her last name

when I got divorced—

she is like a mother.

LEFT: Edith Turner, 96
RIGHT: Ruth Turner, 75

I love living.

 I have a house on a river in Nova Scotia

 and I watch the water coming and going.

 Being a poet is not a choice. It is a way of life.

It comes to me like the water,

 from some invisible well or source.

Joanna Harris

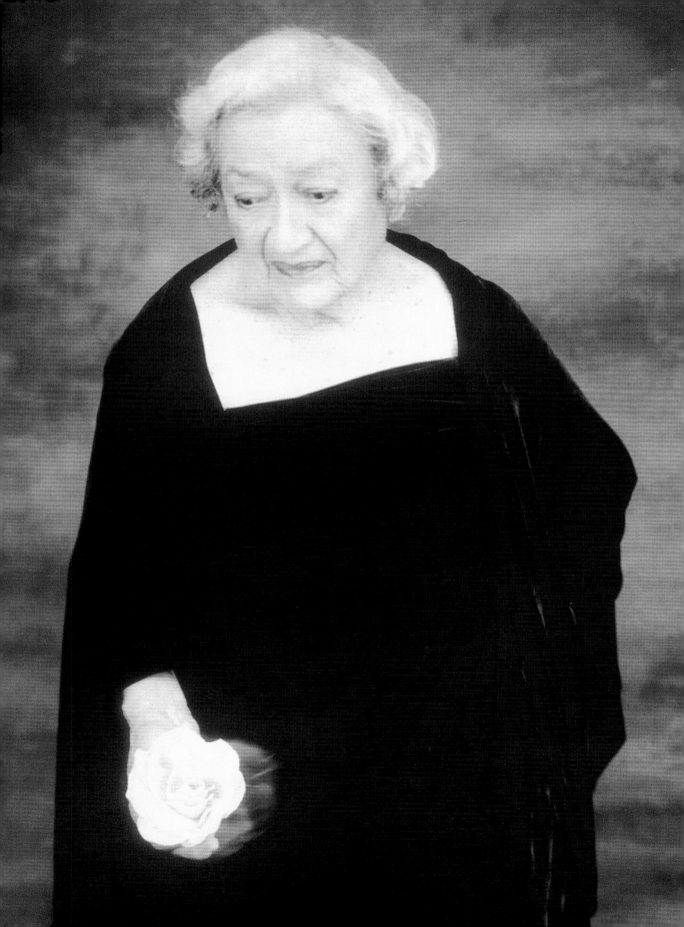

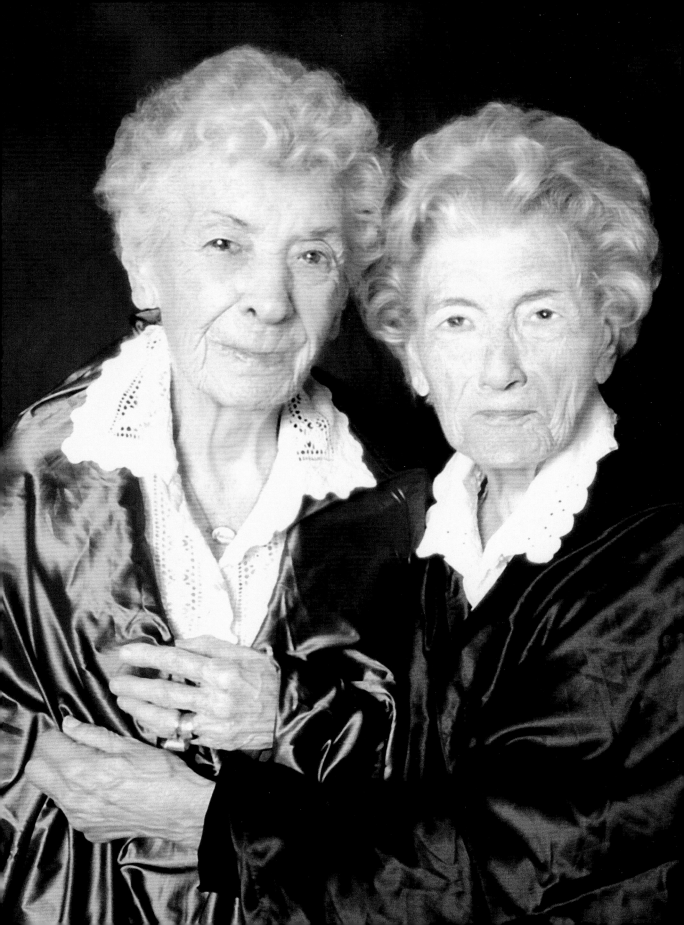

Madeline: We are best friends.

I protect her.

She told me my horoscope when I moved into the home—

I need an Aquarius in my life.

Ragna: You are the best in all darned ways.

In the war,

I made screws for torpedoes.

Now I'm in an old-age home.

LEFT: Madeline Burt, 97
RIGHT: Ragna Solaas, 91

Sister Elise: I was in the U.S. Navy for three years

before being called to the religious life.

Sister Mary Christabel was in the Canadian Navy.

We both feel like

we are grandmothers.

We have nurtured more children over the last fifty years

than if we had been married.

Sister Mary Christabel: To be authentic and real,

that is what is most important.

Our sense of community and prayer

has continually opened me to deeper levels of

understanding and love.

LEFT: Sister Mary Christabel, 80
RIGHT: Sister Elise, 80

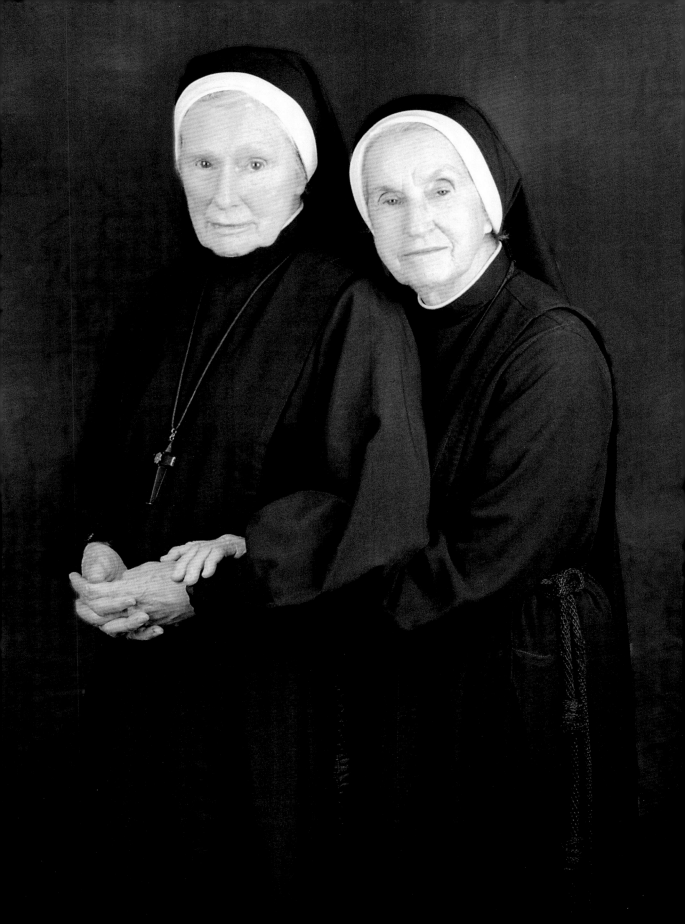

Betsy Brown, 69

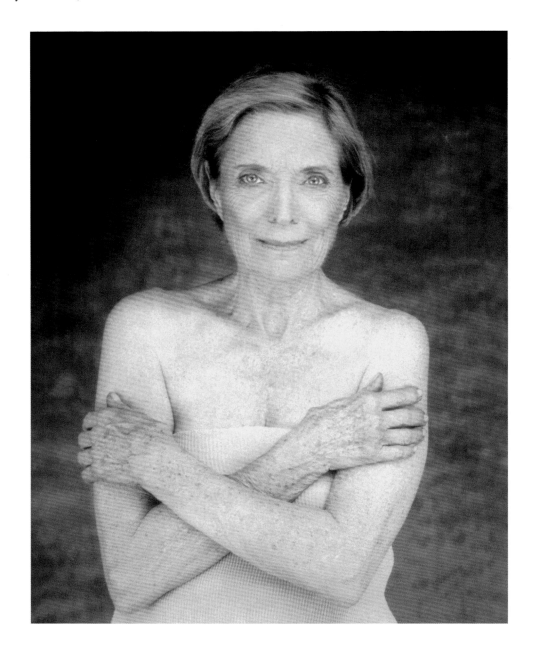

Let it go.

If it's bothering you, let it go.

Live it, do it, enjoy it—

don't hesitate!

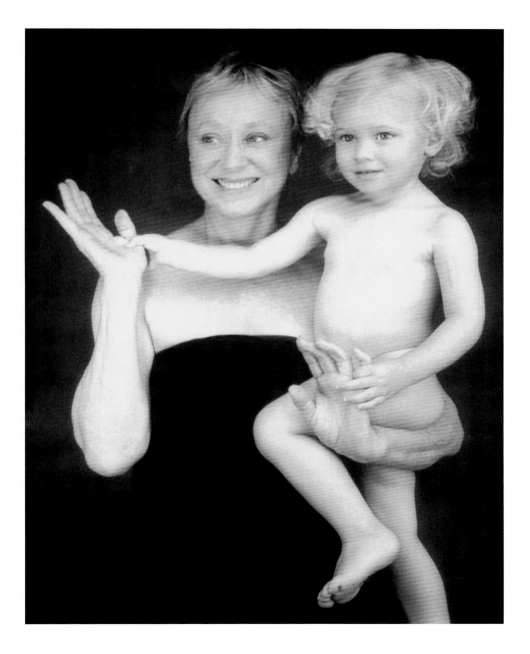

Jane Greenwood Edwards, 67, and granddaughter

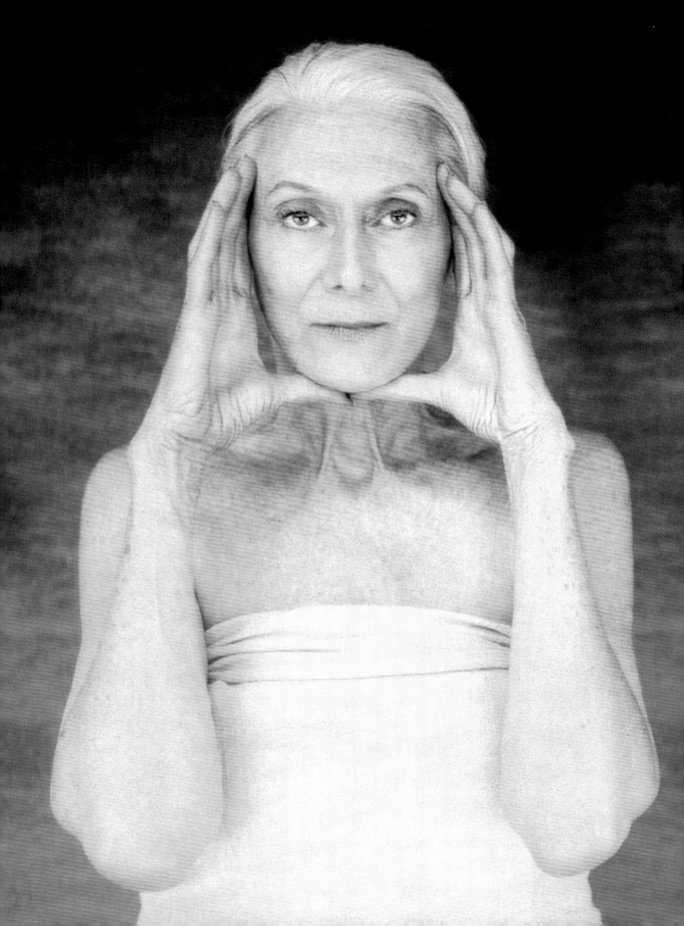

The most important thing

is to try and enjoy life—

because you never know when it will be gone.

If you wake up in the morning

and you have a choice between doing the laundry

and taking a walk in the park,

go for the walk.

You'd hate to die and realize you had spent

your last day doing the laundry!

Christine Lee, 67

The greatest gift

we can give to the world is creating

a continuous,

uninterrupted loving family structure.

Aldona Laita

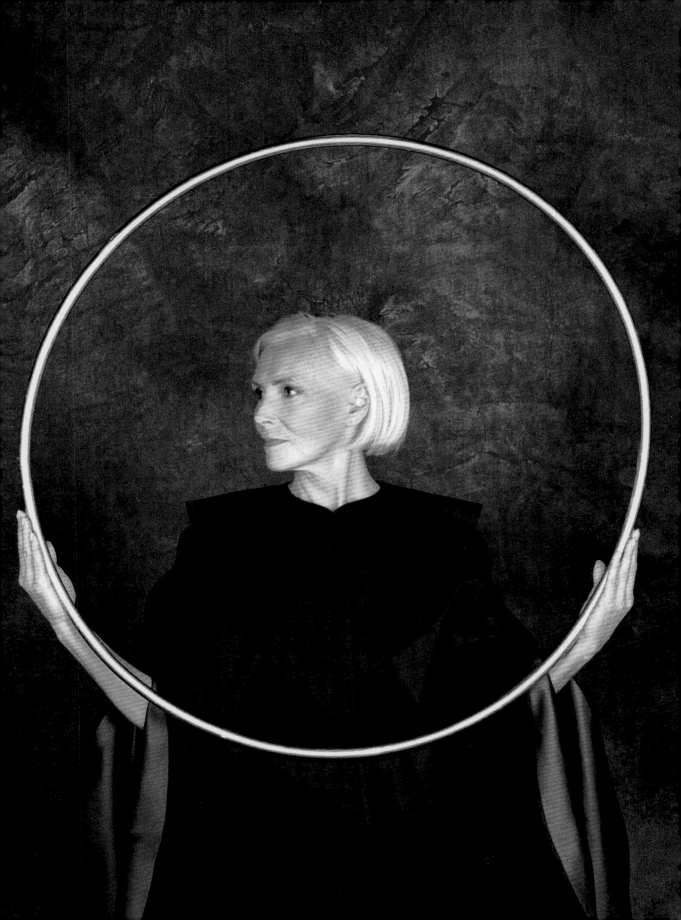

Melissa Hayden, 78

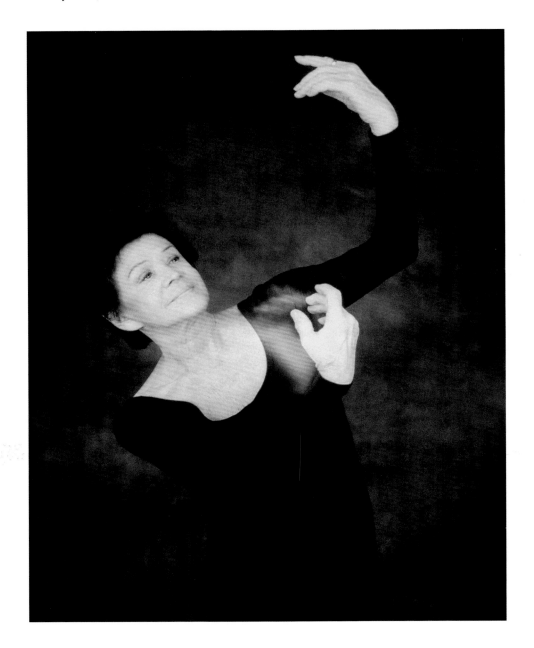

Life burned inside me—

it was released in dance.

Dance has been the mainspring of my life.

I had a school and ballet company at Carnegie Hall for

thirty-five years. I am a people person. My mission has been

to bring joy into others' lives, and let them fulfill their potential—

whatever it might be.

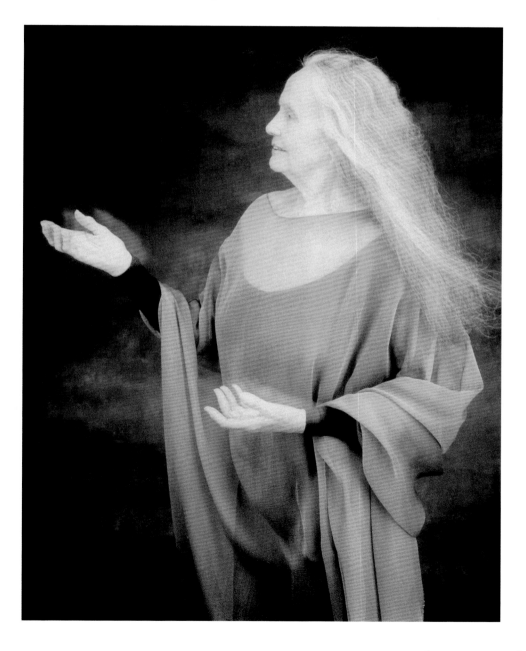

Christine Neubert

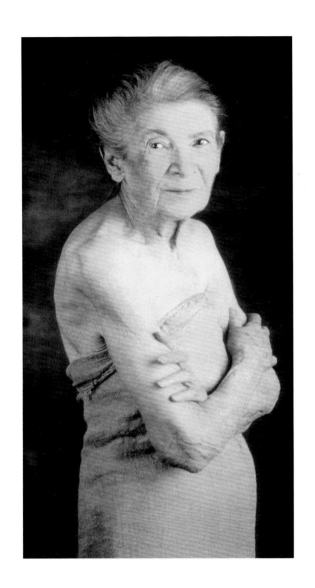 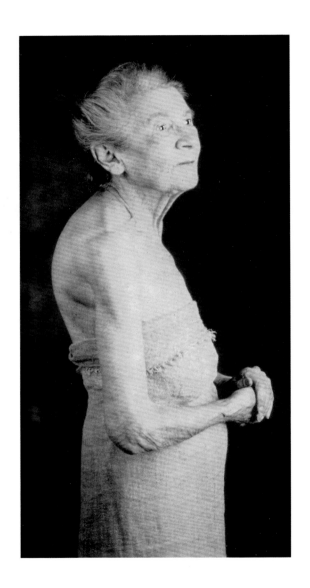

Andree Ruellan, 95

Be yourself.

If you have talent, don't neglect it.

One of my great life joys was marrying an

artist who was my equal. It made

my life so much richer than those of

most of my friends.

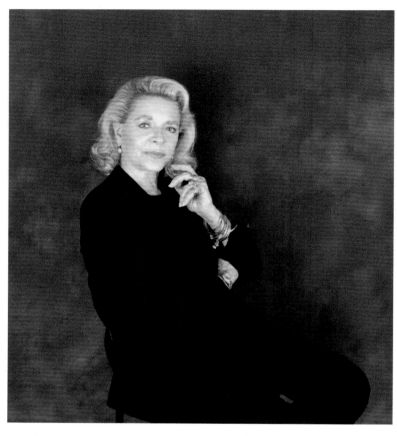

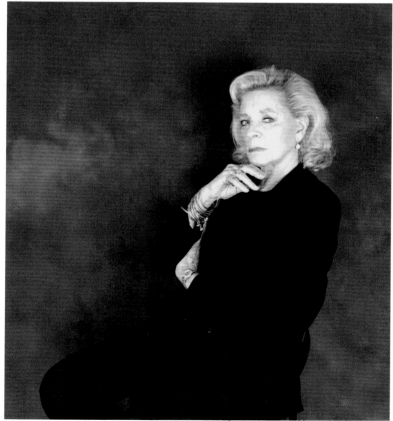

Being strong is okay,
but I don't like arrogant.
I live at the Dakota and
sometimes I feel like moving,
but what would I do
with all the things I've collected
over the years?
I have so many "things,"
I guess I'll never move.

Lauren Bacall, 77

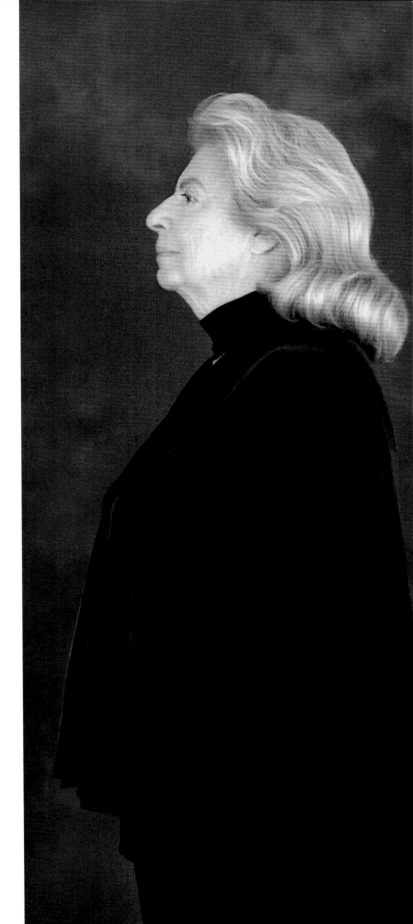

My mother died last December

at age one hundred and two.

She died peacefully

in her own bed

with no medication.

What I learned from watching all

this closely was that we are

all similar at the beginning

and again at the end.

Cornelia Bessie

People often remember me

from my performance in *Roots*

or from having been married to Miles Davis.

But what I'm most proud of (except my daughter, of course)

is the work I've done recently with a school

named after me in East Orange, New Jersey.

I've been very active in their scholarship program

and recently initiated a master class in drama.

It's so gratifying to be involved in a program

where I can see real changes.

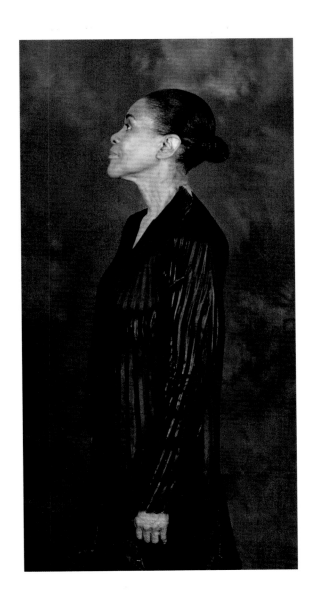 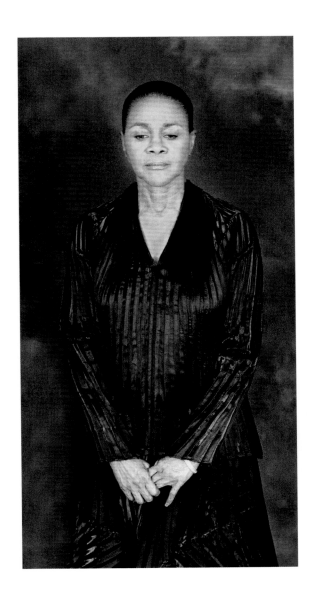

Cicely Tyson, 68

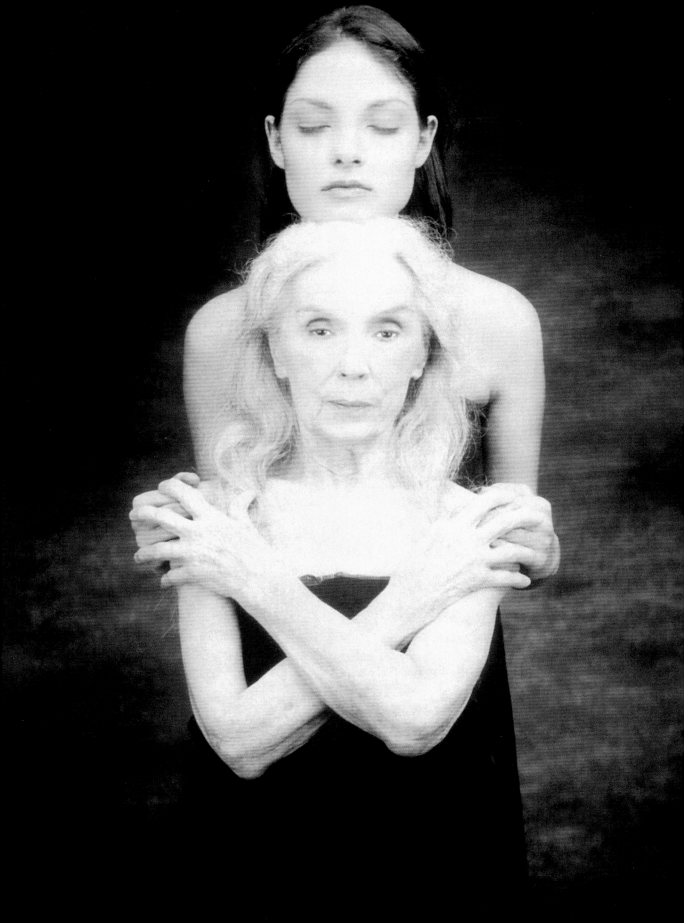

The best thing

about getting older for me

is never having to wear

high-heeled shoes again!

Jan Owen and friend

I danced for years

 with the Martha Graham Company.

I teach now, and we are in an era

of maximum flexibility,

 which is not always deep-down dancing.

Martha Graham used to say flexibility is easy,

but to release meaning is what is important.

 All that facility does not make

 the audience's heart beat faster!

Mary Hinkson Jackson, 76

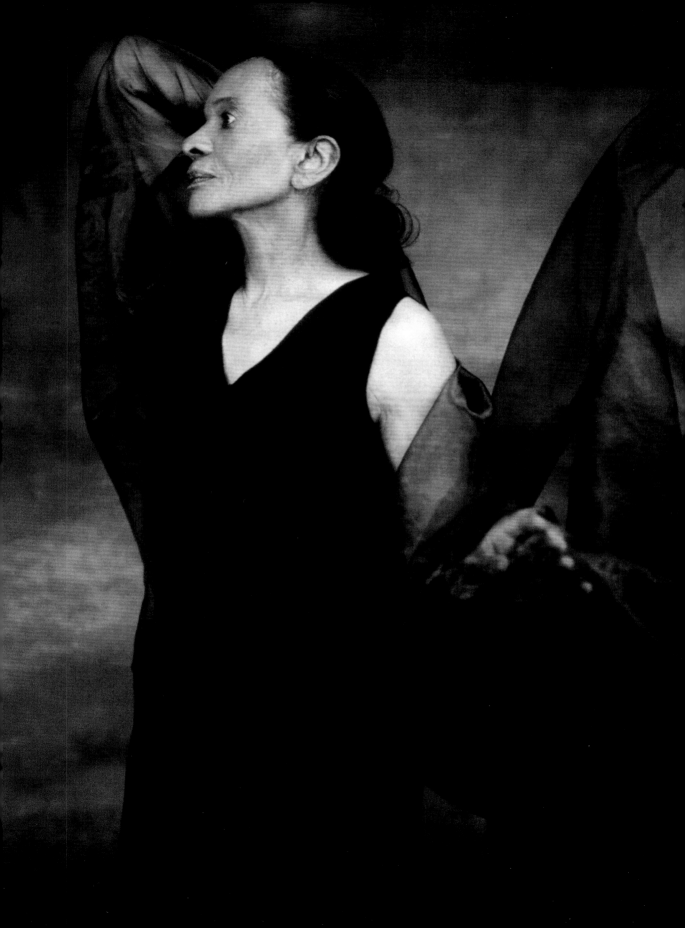

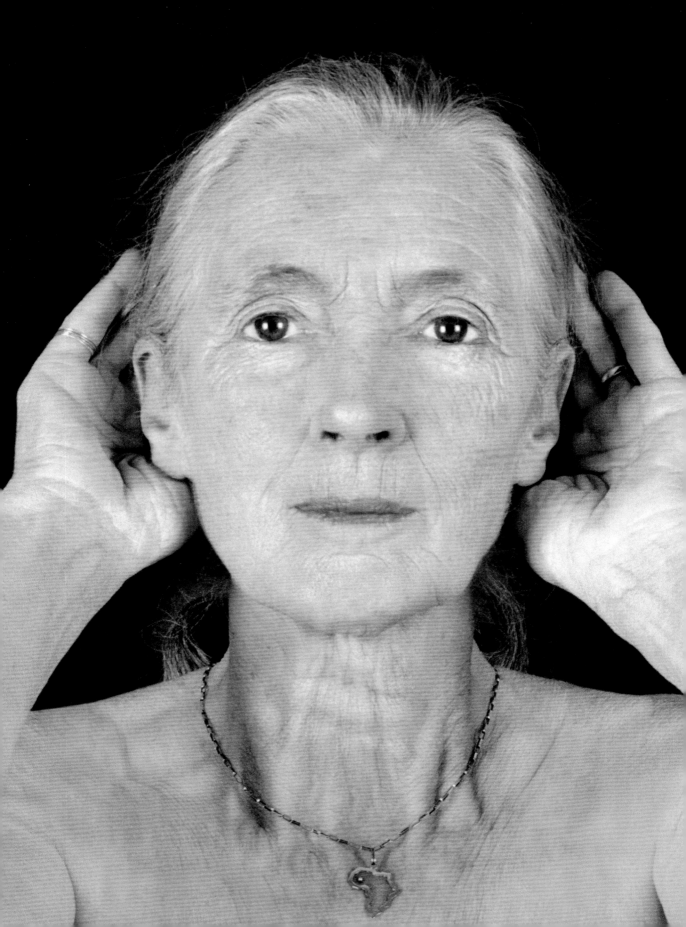

Despite the ongoing
destruction of our environment,
I still have a strong feeling
of hope for all the creatures
on earth.
I have used the wisdom
I've gained from studying the
chimpanzee for forty years
and I now travel three hundred
days a year
in order to share my message with
the world.
I couldn't have done that
when I was younger.

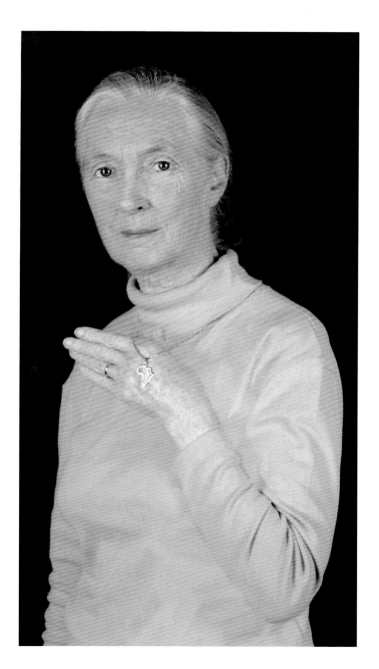

Jane Goodall, 67

Lily Tomlin, 62 Paula Laurence, 85

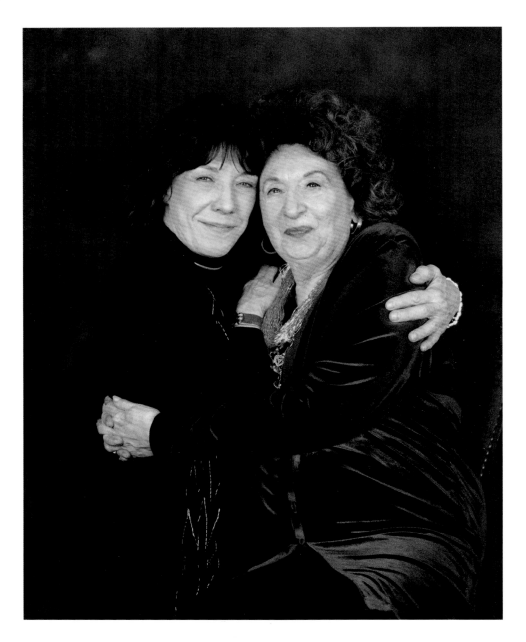

Paula: Being a godmother is about

joy and love and passing all that along!

Lily: Paula is my spiritual and artistic godmother.

Meeting her twenty-five years ago

84 was a kind of providence or fate.

Film is a kind of photography of the mind.

 That's why Marlon Brando was so fascinating—

he was a whole innovative force

 and you saw that in his face.

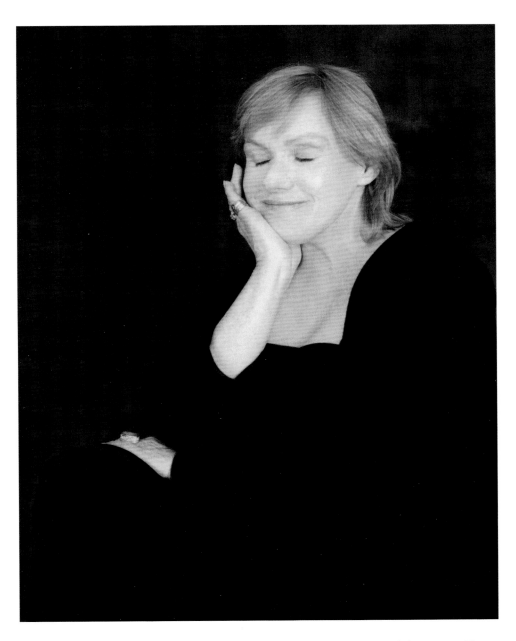

Tammy Grimes, 67

I practice singing every day.

I worked with all the greats—

Irving Berlin, George Gershwin, Cole Porter, Richard Rodgers.

They are all dead now.

I'm the only one left who knew them

and can still sing.

I tell younger people to keep working,

so when they get as old as me,

they have something that keeps them in the game!

Kitty Carlisle Hart, 90

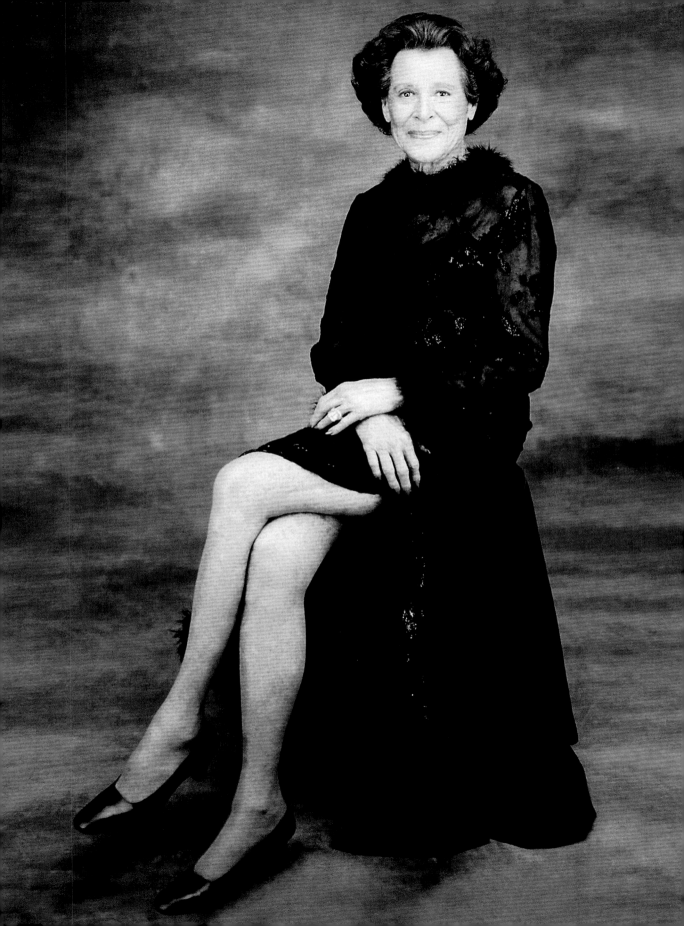

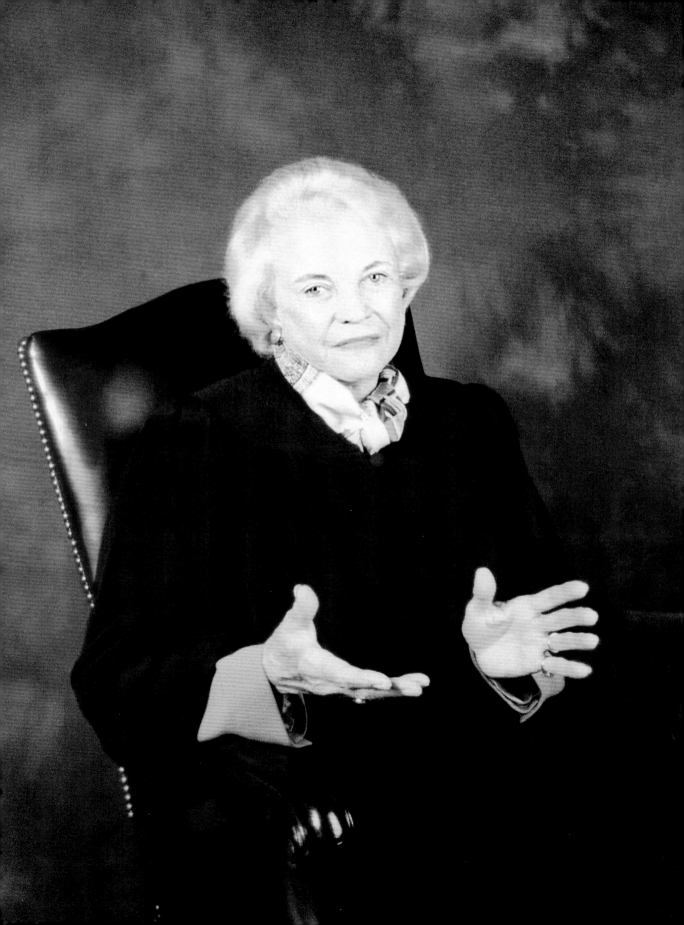

My grandmother had total focus,

an attribute that deeply impressed me.

She also had the ability

to make me feel like I could do anything,

that I could be a leader.

She focused all of her positive spirit on me.

Live today.

"This is the day that the Lord has made."

My father used to say that to us,

and I've never forgotten it.

Libby Lyman, 75

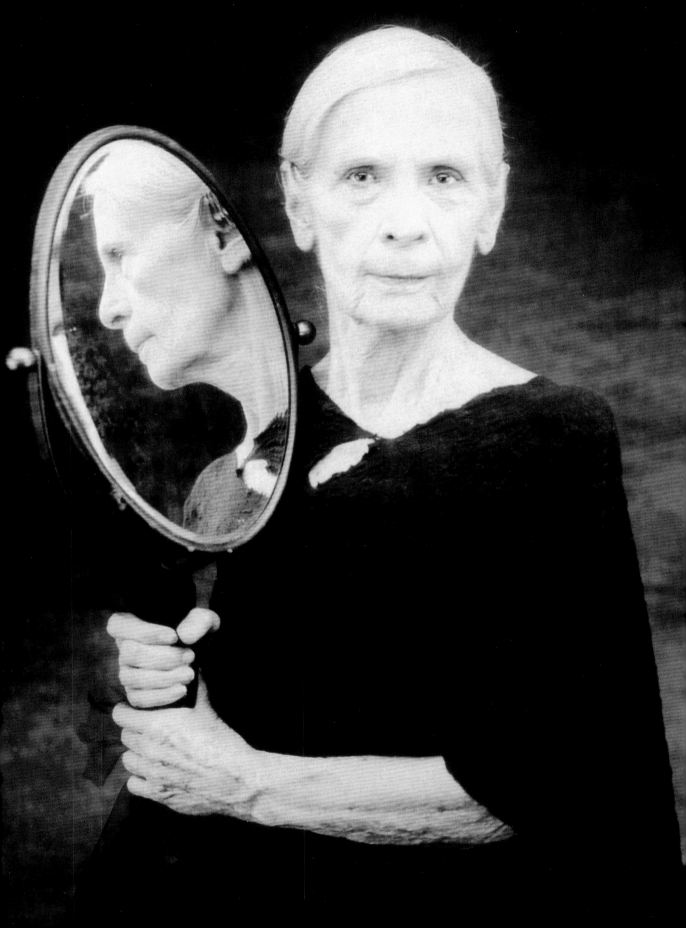

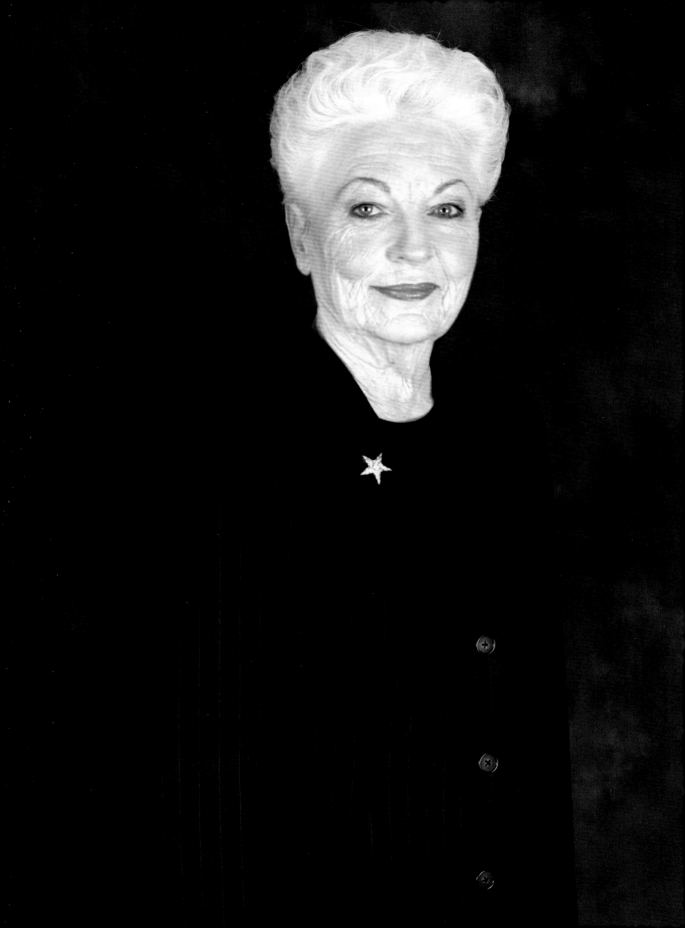

Being governor of Texas

was a great moment in my life.

But I have reinvented myself since then

and made major life changes,

like getting myself into the gym!

I have very different priorities now.

Ann Richards, 68

I was the creator of Mattel.

I had the idea of making a doll like Barbie

when my daughter Barb

started drawing paper dolls in adult clothes.

We got so much fan mail for Barbie—

they asked me to make a boyfriend for her,

so I made a male doll I named after my son Ken.

I had to convince the factory of my idea.

They were shocked and astounded by

the success of the Barbie line.

Ruth Handler, 84

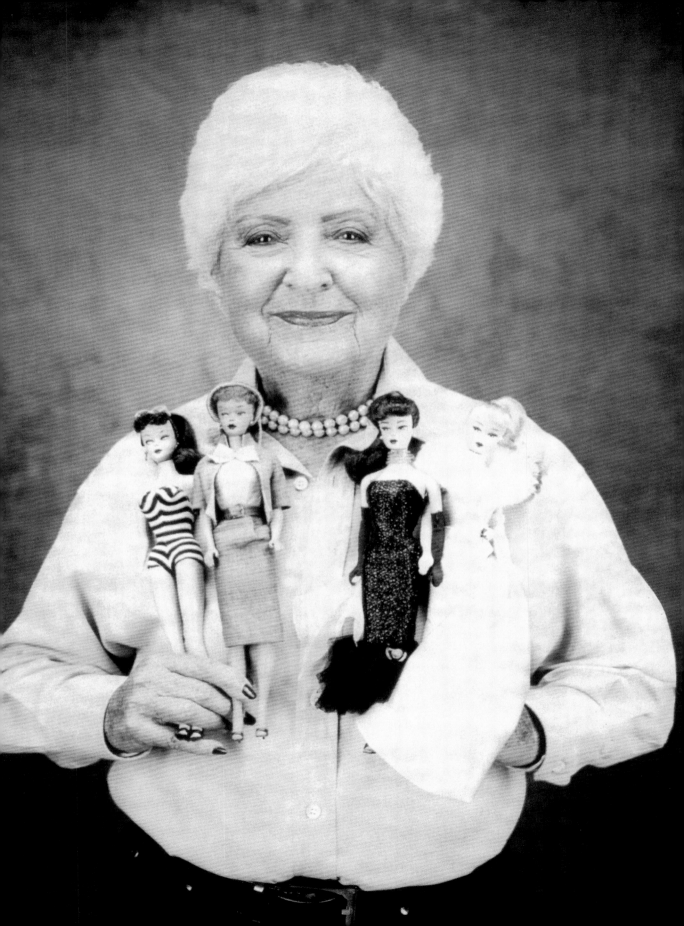

Joan D'Arcy, 70

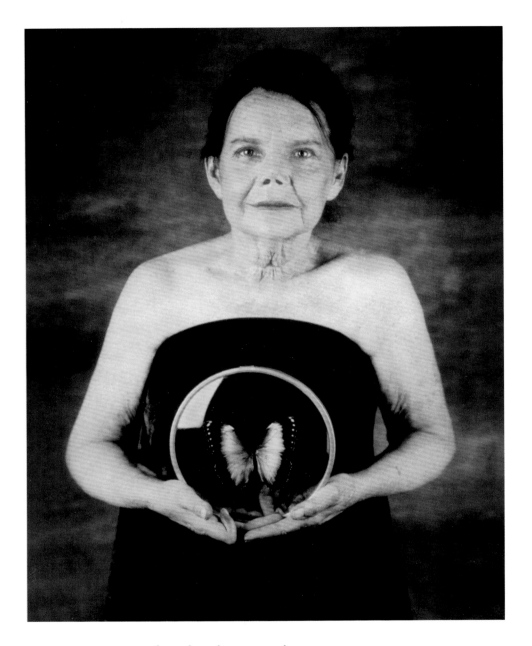

Life is short but it is wide—

it is so magical—filled with mystery and wonder.

Butterflies are special to me.

Their life is the examined life—

it has passion, purpose, and a destiny.

I've realized that people are more unique than I ever thought.

I used to presume others saw things like I did,

but of course they often don't.

To be wise is to have respect for each person's unique journey and integrity,

and not expect them to be or think like you.

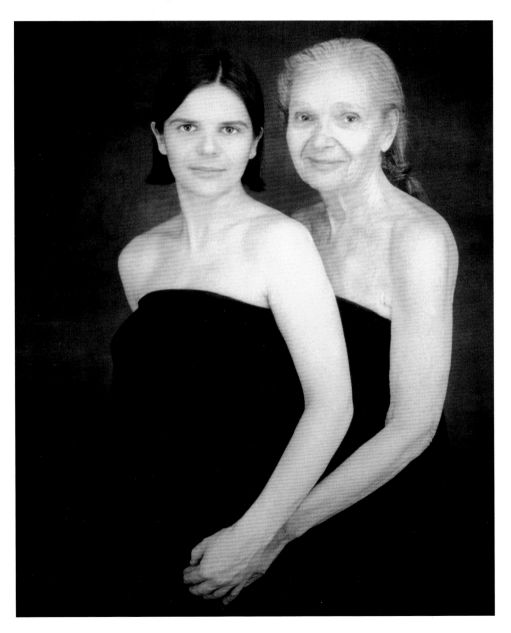

Annette Covino, 74, and neighbor Bernie

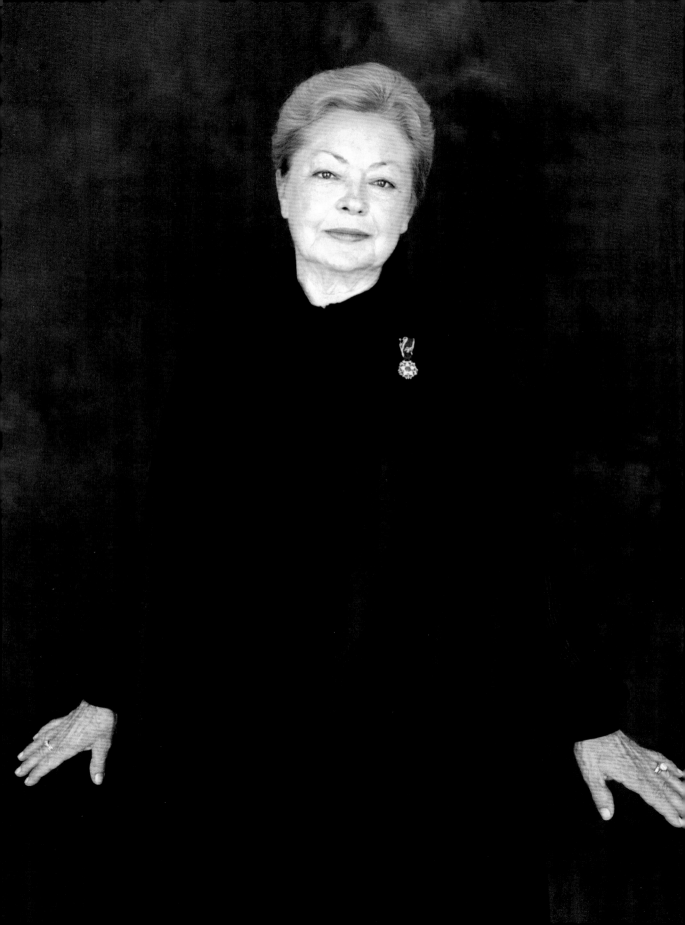

I would like to get control of the AIDS epidemic.

We have made a lot of progress,

but it will probably be ten years

before the vaccines are available.

I may not live to see it.

I would also like to see lesbians and gay men

accepted as equals in society.

Mathilde Krim, 70

A sage knows there is both

the wisdom of the universe and of man—

and finds a balance between the two.

Clara Holm, 101

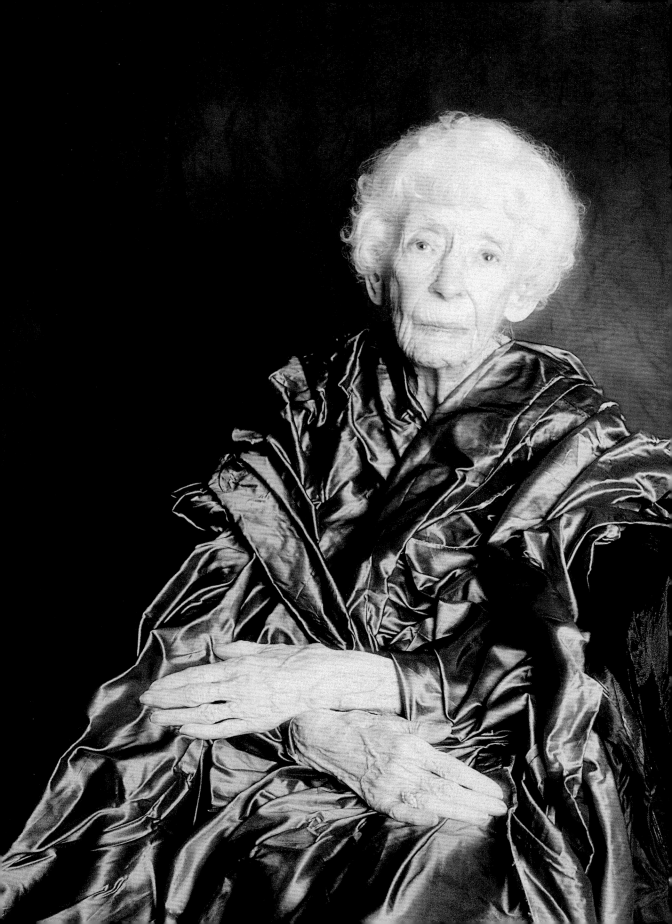

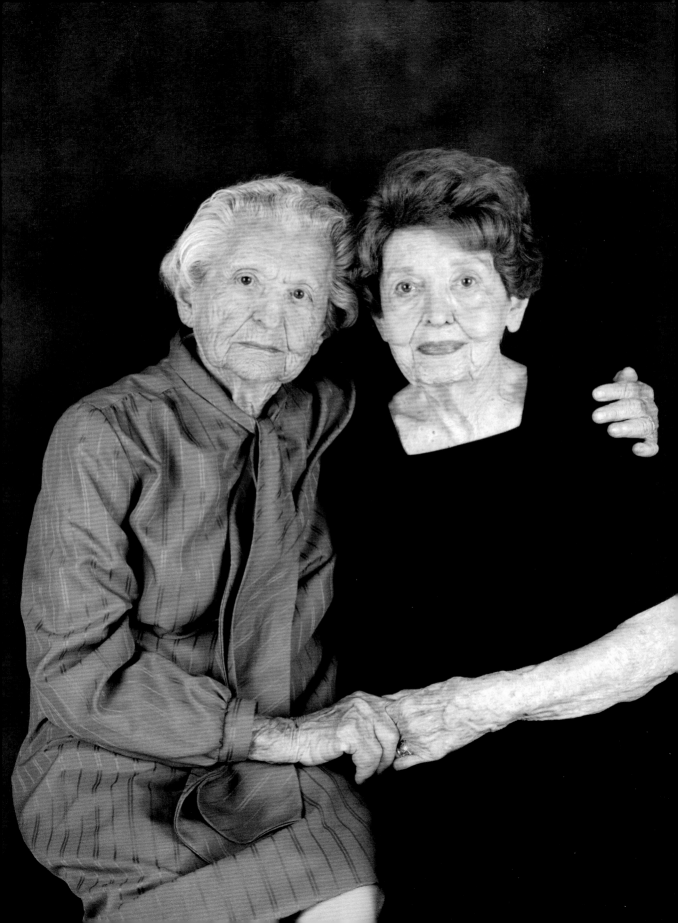

Lenore: I conduct nature tours in Vero Beach,

Florida, where I live.

People can't believe my age.

Even the ones thirty years younger can't keep up.

I also exercise by doing the *New York Times*

crossword puzzles every week.

Helen: Friends call me "happy."

We are blood sisters who married cousins.

Lenore met her husband at my wedding.

I had my own television show,

and back then you couldn't mention sex, cancer, or the word *breast.*

They were all no-no's.

How things have changed!

LEFT: Lenore Reichart, 98
RIGHT: Helen Reichert, 100

Stephanie: My aunt never married,

but she loved children.

She passed away shortly after this photo was taken,

and left me her home. It was a tremendous gift,

but more important is the fact that I can feel her presence.

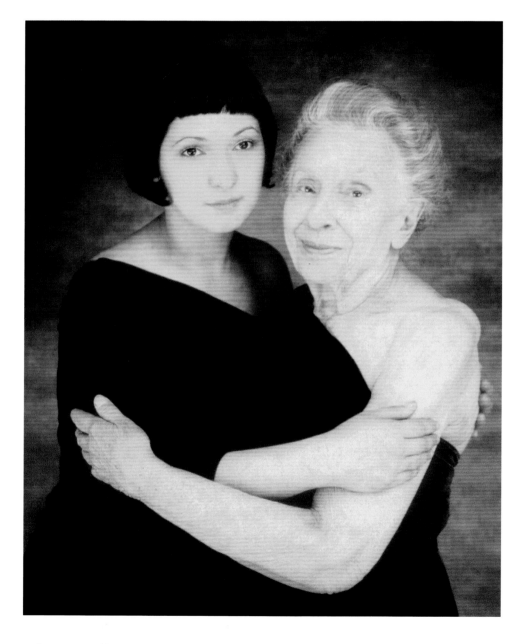

Ann Sederocanellis, 83, and grandniece Stephanie Lienhard

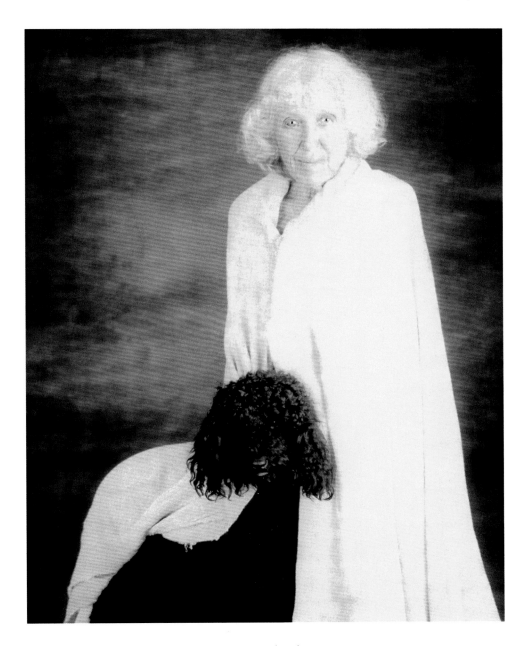

I've been working on a new book

of statuary Madonnas—

their peace and serenity draw me in.

My photographs have always been about

quiet things and revealing light.

Mimi Weddell, 85

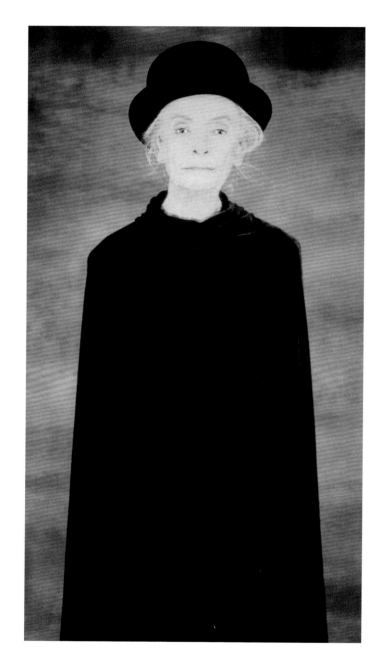

I couldn't live

without heroes.

Years ago I was wild about

Dylan Thomas—

I loved his voice and the images

he gave us with his poetry.

George Washington—

I adore him.

He was a great dancer too.

And just looking at a picture

of the Dalai Lama makes

me peaceful.

Shakespeare too—I don't feel alive

unless I've read something

from him before I go to bed.

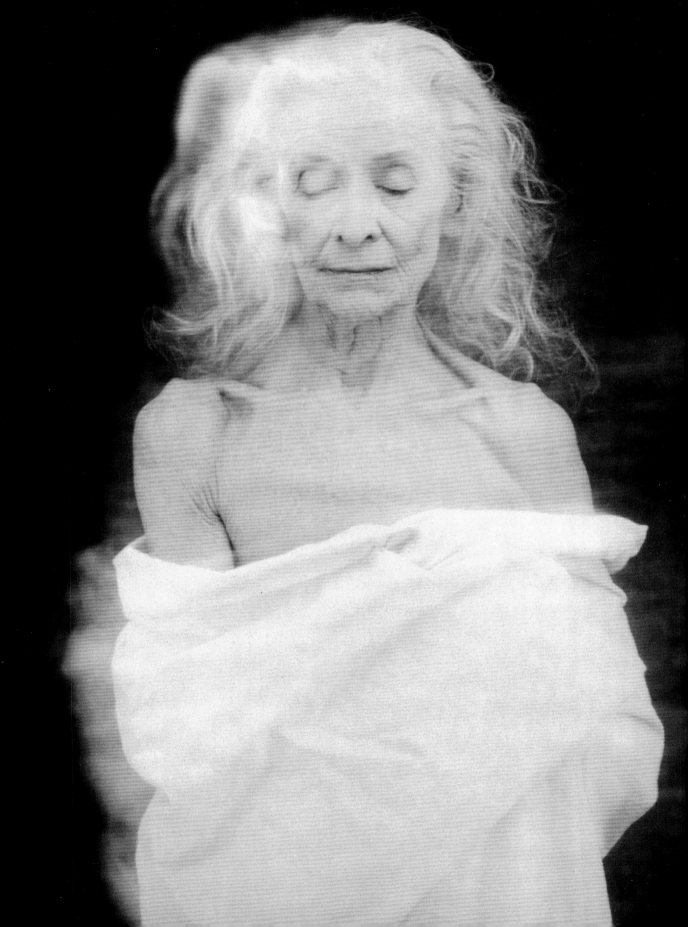

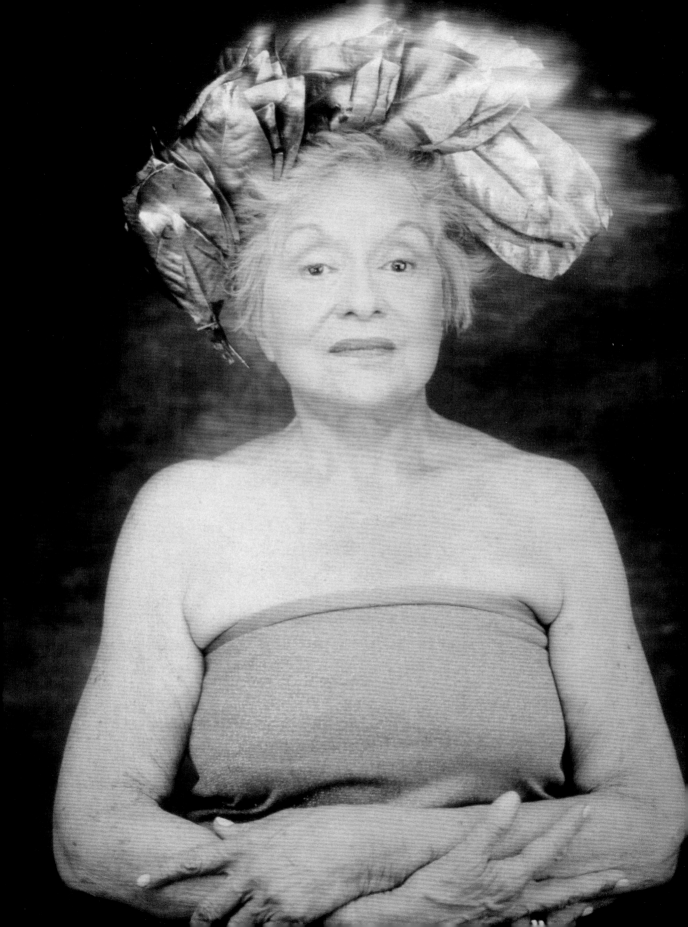

I keep telling my young friends

that sex keeps getting better.

After dealing with all of life's trials and tribulations

for so many years,

you just realize that there must be a higher power.

Once you realize this, you can let life unfold.

You get to the point where you just say,

"I'm not going to worry anymore;

I've done that long enough."

Jeanie MacPherson, 72

Follow your dreams

and don't let anyone turn you around.

I always tell my grandchildren to believe in themselves

and never be afraid to go out and seek.

You have to go out, work hard,

and find it yourself.

Dolores Fleming, 65

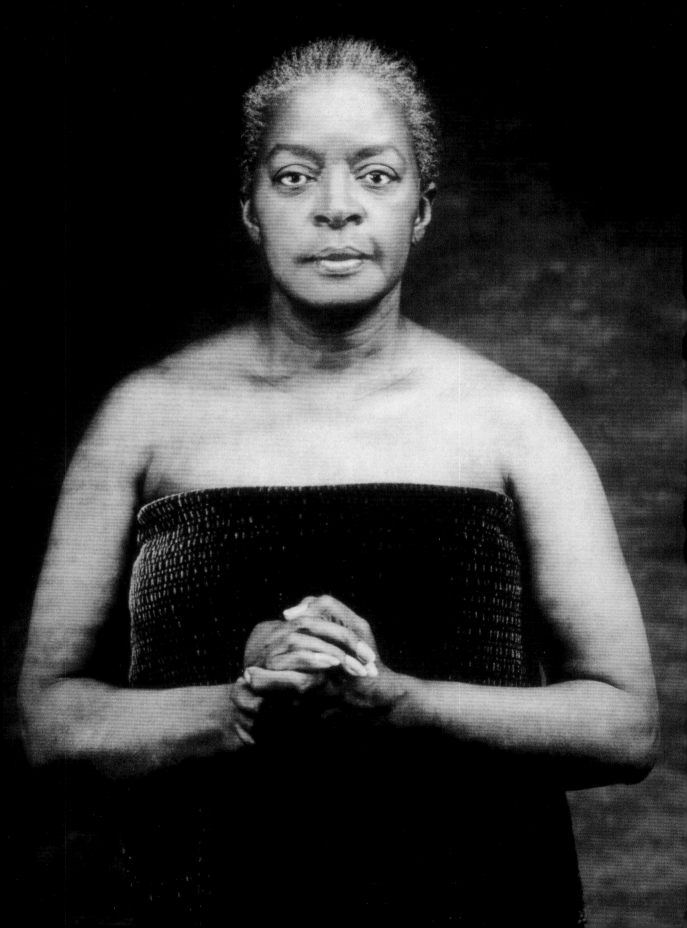

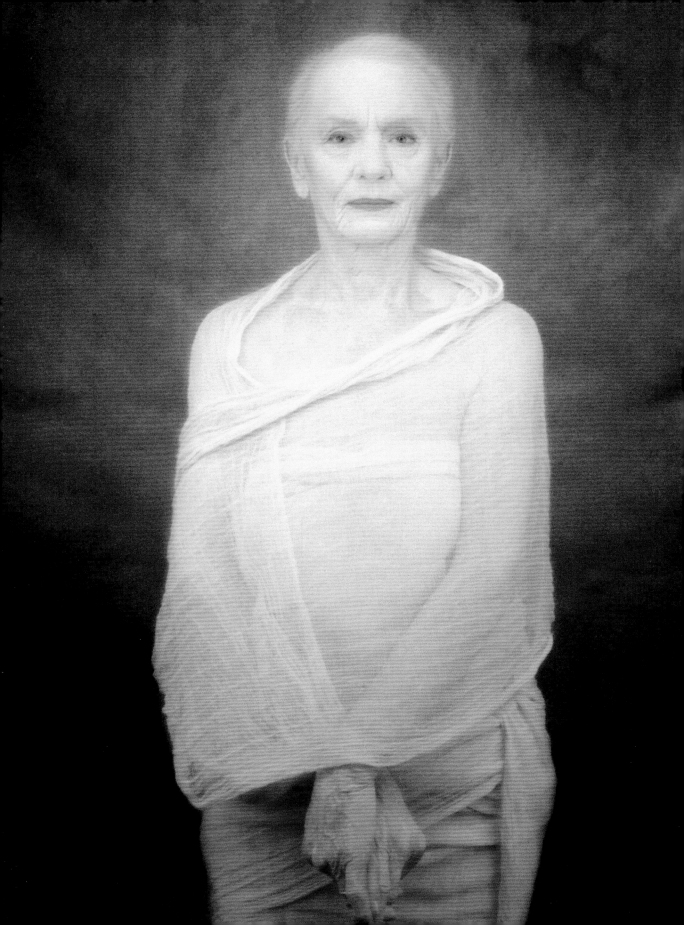

I'm shocked

you wanted to photograph me at this moment,

with my hair just beginning to grow back

after the chemotherapy.

But you're the artist.

I trust your ability to present me as you see me.

I'm in your hands.

Jessica Tandy, 84

Liz Smith, 78

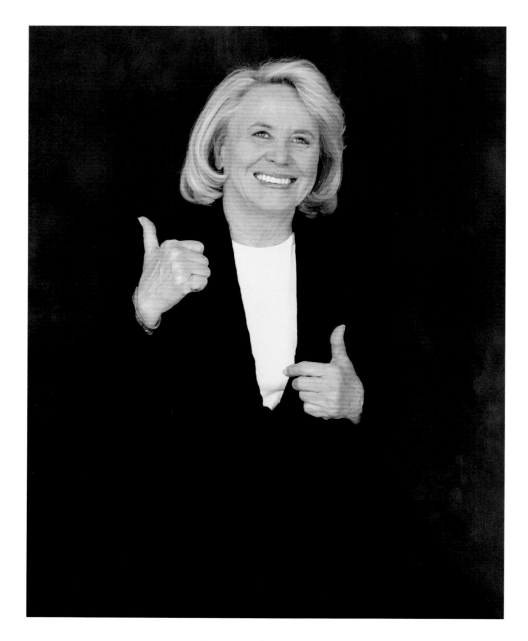

I'm a news junkie.

Being a gossip columnist is kind of an addiction—

I thrive on it. I can't imagine not working.

The key to success is loving your work,

but I don't think there is any easy work. That's why they call it work!

Tippi Hedren

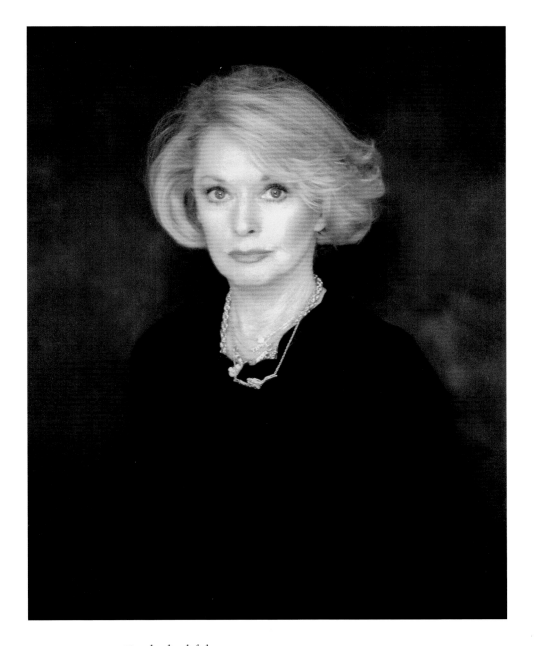

I've had a lifelong interest

in protecting endangered animals.

I created the Shambala Preserve

to protect endangered animals and to provide

a meeting place of peace for all beings.

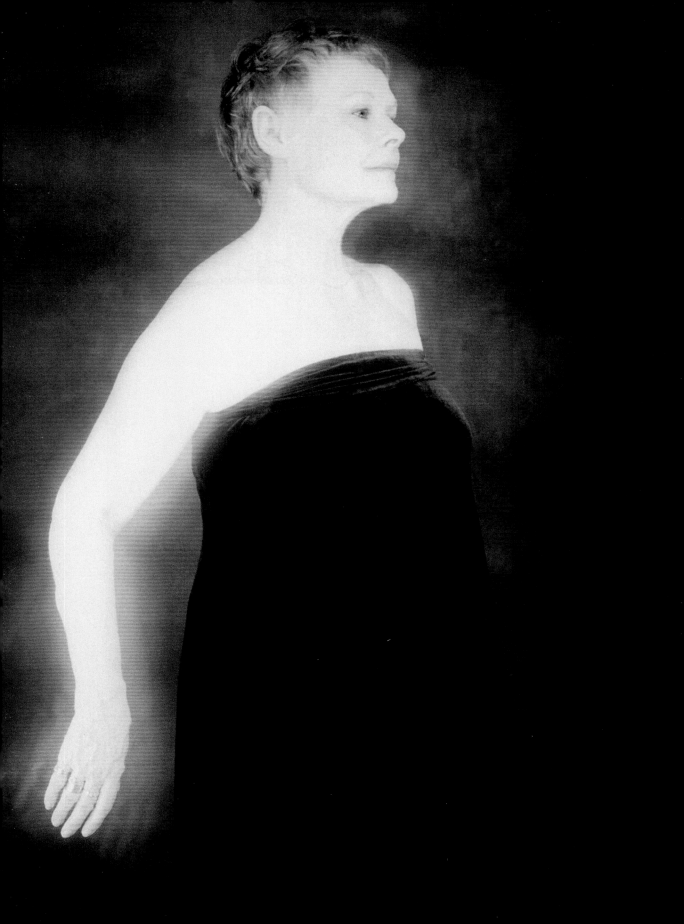

I went to a Quaker
boarding school. They believed
in fostering the one or two
things they saw as
your center.
For me it was acting.
I've never been interested in
"success," which is so ephemeral.
For me success is having
the respect and love of people
who truly know you.

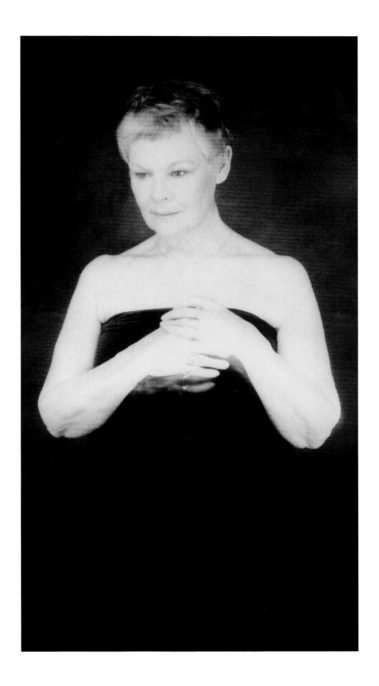

Dame Judi Dench, 67

We were born July fourth,

and the nurse wrapped us in one blanket.

Back then they didn't have sonograms,

so our mother fainted when she saw us. She thought we were Siamese,

because all that showed coming out of the blanket

was our two heads!

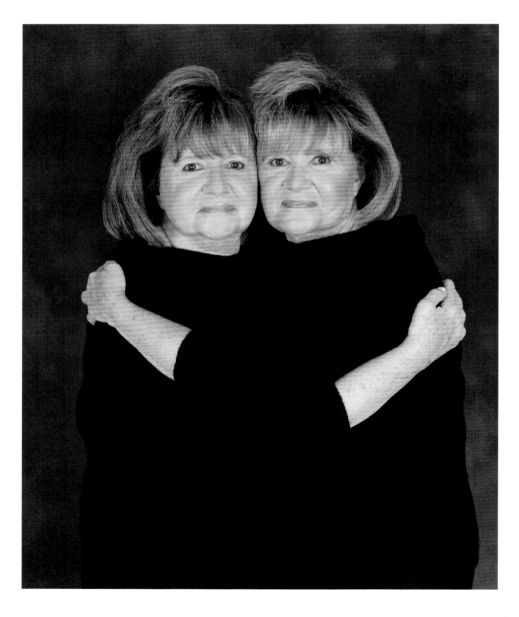

Fran Rappaport, 65 Ann Cole, 65

Phyllis Silverman, 90

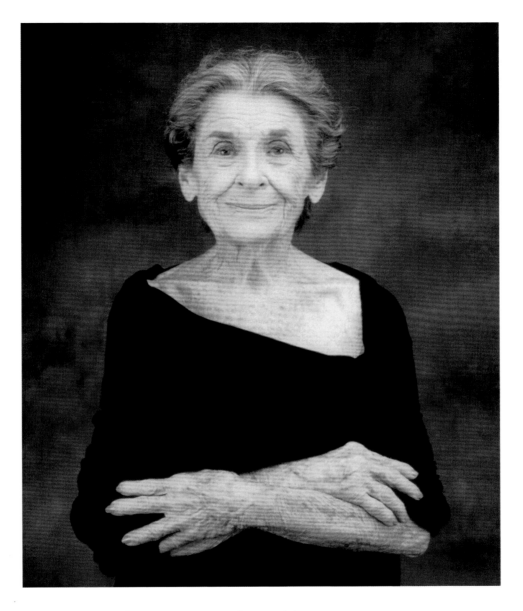

This is a great period in my life.

My challenge now is to paint with my true voice.

I've been painting all my life,

but somehow I still haven't been able to

express my deepest vision. Not yet, that is!

119

I don't need a mirror to see how I look.

Long ago, I realized the inner self

is visible if you present yourself truthfully

and authentically.

I'm comfortable with getting older.

I have lived a good life.

Geraldine Smith, 70

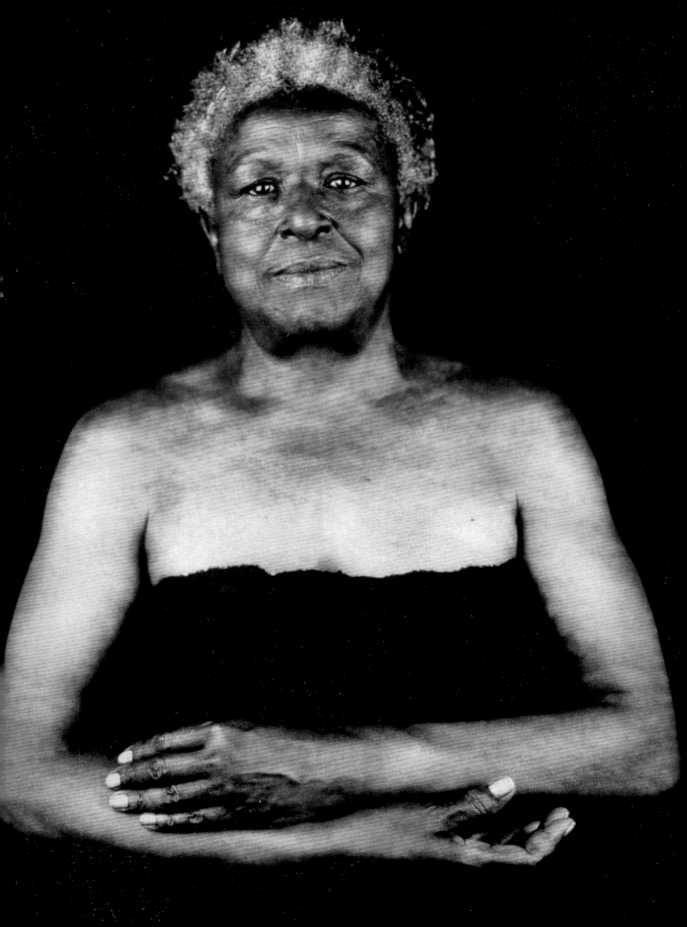

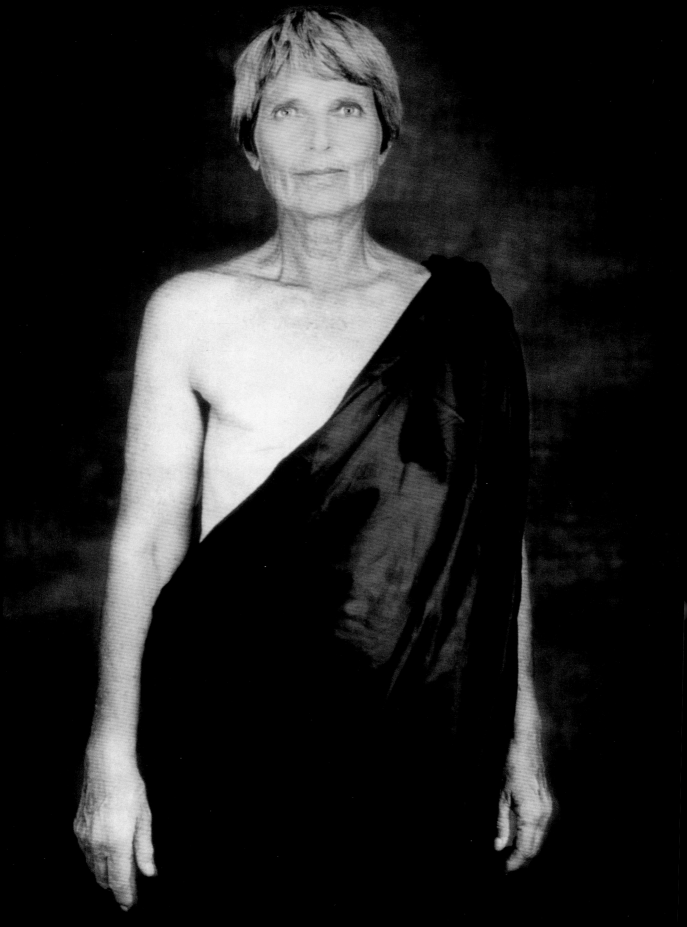

When I look at my body I see a survivor.

I am one breasted—but I am more.

I am more compassionate

and open than I was before.

Krista Gottlieb, 70

Expect the unexpected—

life is never what we think it is going to be.

My twins were always together:

if one had an accident,

the other would have one right after.

They are really one egg split in two,

so they are still close and see each other daily.

LEFT: Colleen Kenyon
CENTER: Kathleen Kenyon, 76
RIGHT: Kathleen R. Kenyon

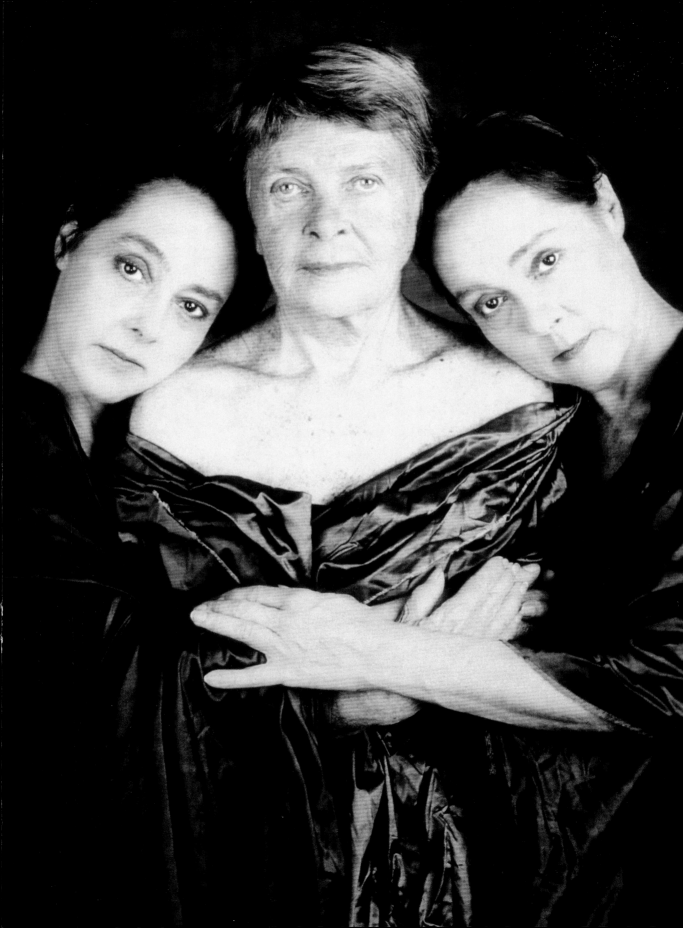

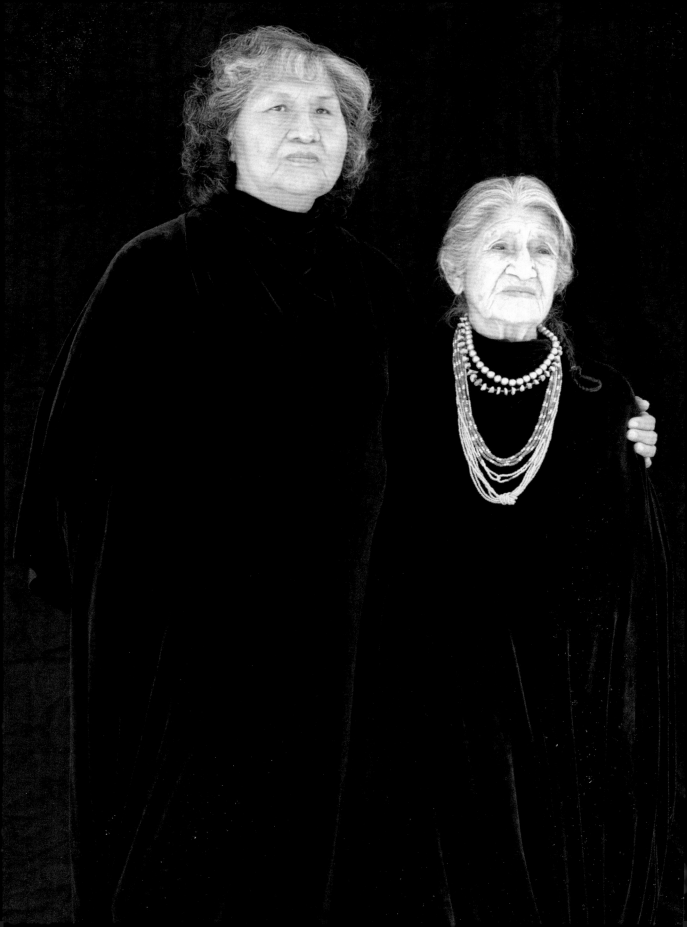

Angelita: If you're good to people,

they will be good to you.

That sounds simple, but it's very true.

Constance: I feel I'm on my second life

and I am blessed to be able to help others by listening,

holding, and praying.

I enjoy a simple, humble life.

I honor all natural things, especially Mother Earth.

She is a great example for us all

because she nourishes without discriminating.

As an Indian, I pass on my culture

by word of mouth and by living it.

LEFT: Constance Mirabal, 74
RIGHT: Angelita Martinez, 92

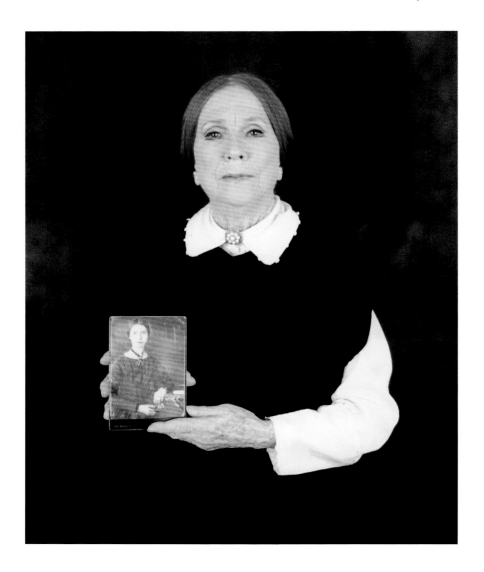

After playing, or more correctly transforming

 myself into, Emily Dickinson for twenty-five years,

I am still awed by her.

 She was a free soul and an eccentric. For her,

 words were life; sacred beings, phosphorescence. To

 find that light within—that's the genius of poetry.

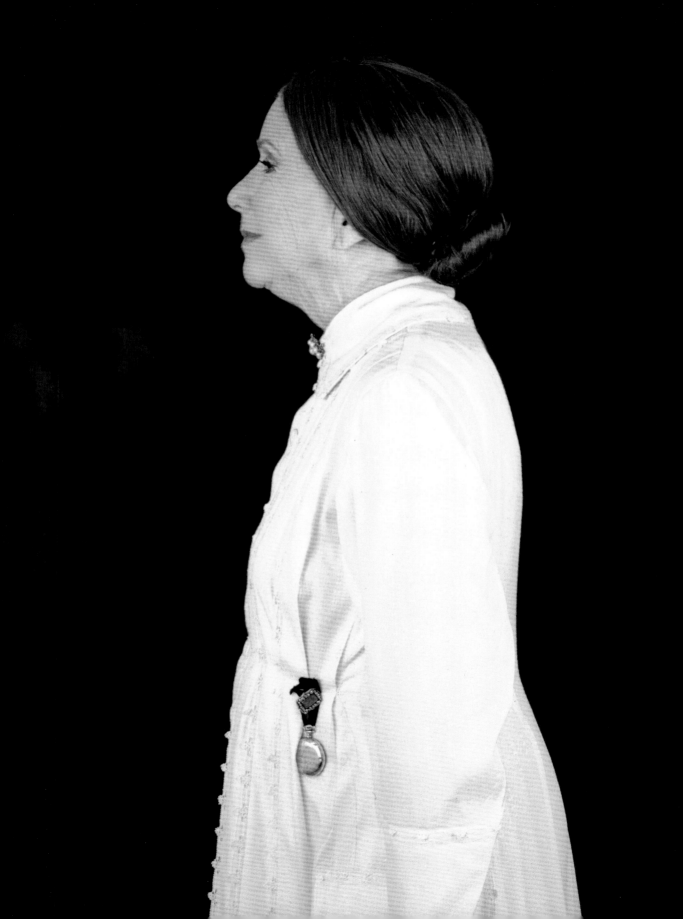

Ever since I went public

about my illness,

I've heard from people all over the country with cancer.

I'd like to make sure that the drugs

these people need are available to them,

even if they can't afford to pay.

This is where I am focusing my efforts right now.

Geraldine Ferraro, 66

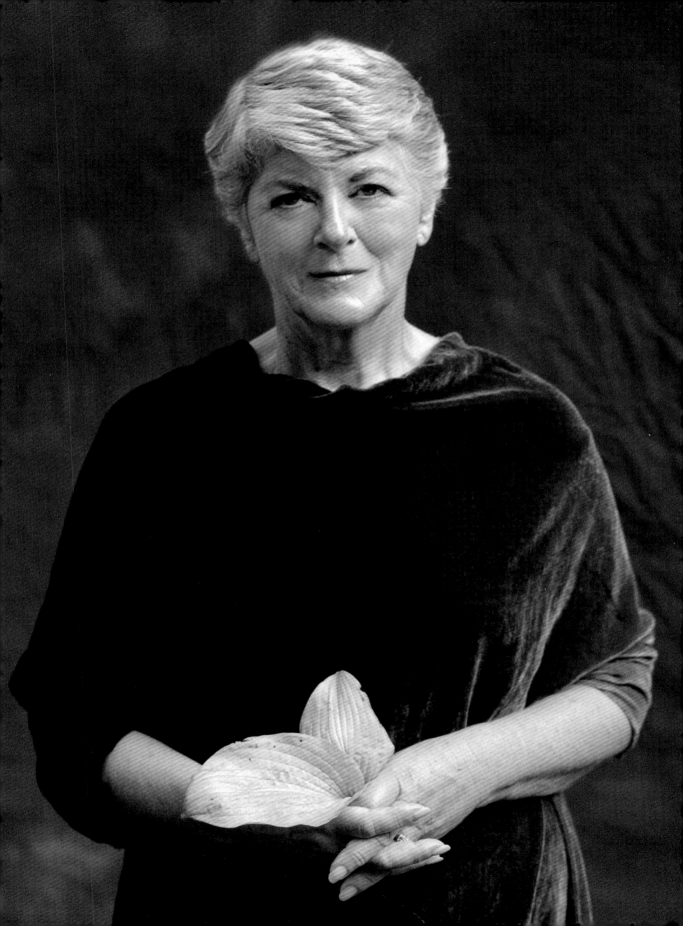

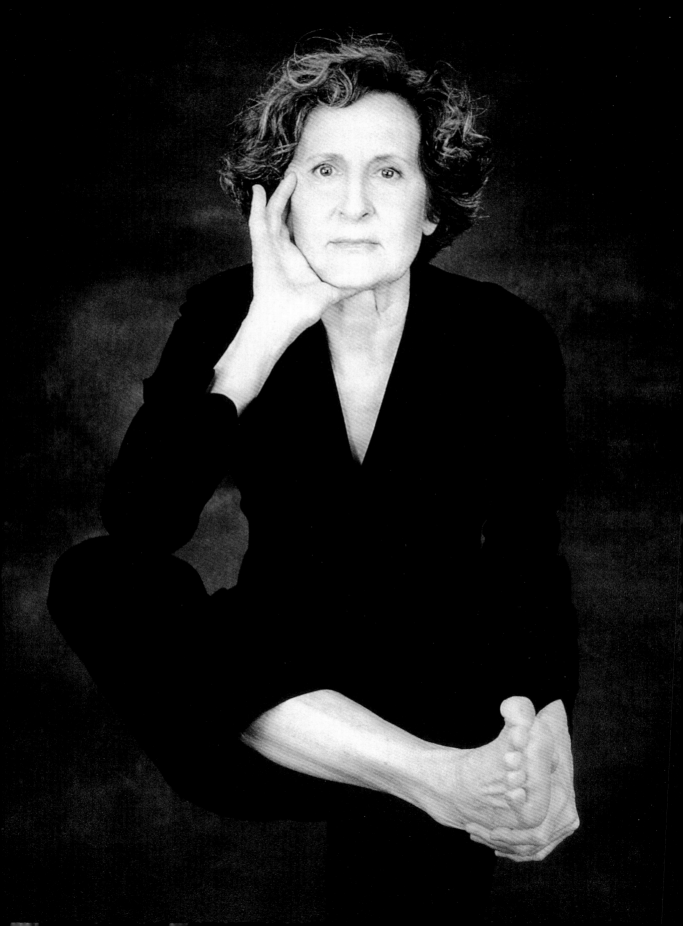

This is the body position

 that feels most like me.

In a strange way, I've felt like an apprentice

 all my life,

 both as a dancer and choreographer.

Now I am taking my compositional skills into

 other arenas—opera, visual arts, drawing.

As I've matured,

 I feel surrounded by a richness of sources,

 a new sense of freedom.

Trisha Brown, 65

As we age,

we have the chance to reinvent ourselves

and to have new adventures.

Arthritis took me away from painting.

Now I use my artistic abilities to design clothes.

As we age, our connection

to our deeper womb powers increases

and we are often blessed

with new gifts of magic.

Ingerborg Ten Haeff, 78

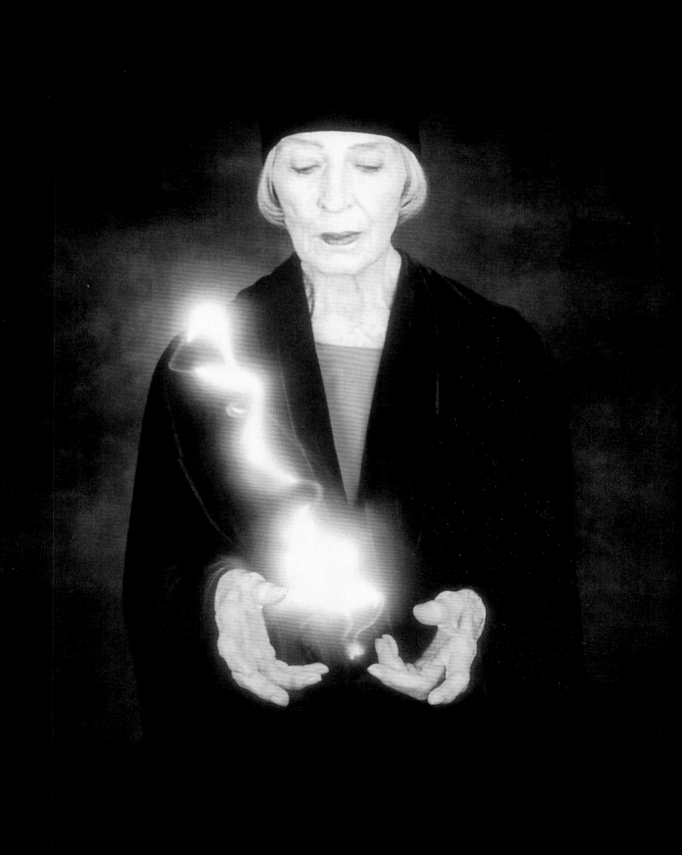

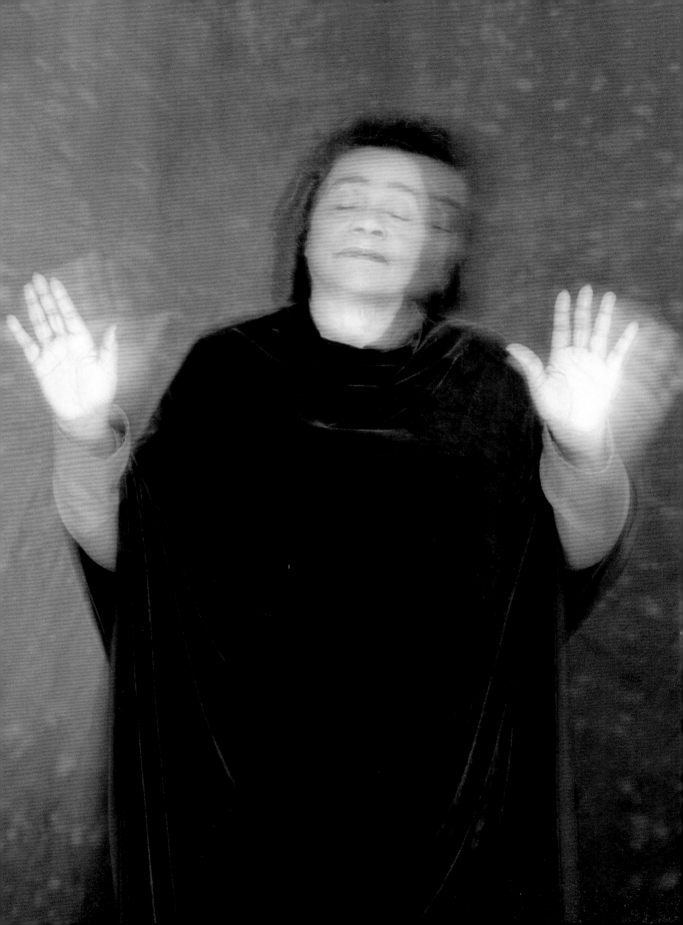

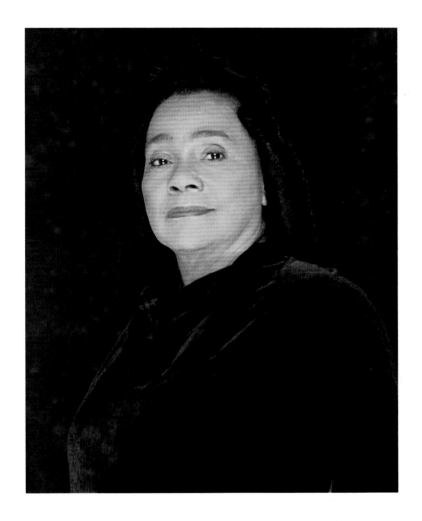

When you age, you become wiser

in so many ways.

You make adjustments for having less stamina,

but you know in your mind what you can achieve.

Experience has shown you the potential of the human spirit.

Committing to what is right,

what is just, and what is good

will bring you fulfillment.

At age seventy-six,

 dealing with your own mortality is a big subject.

I want to be around for a long time.

 My children and grandchildren need me,

 but I want to be realistic about the future

 and live life in as good a way as possible.

Angela Lansbury, 76

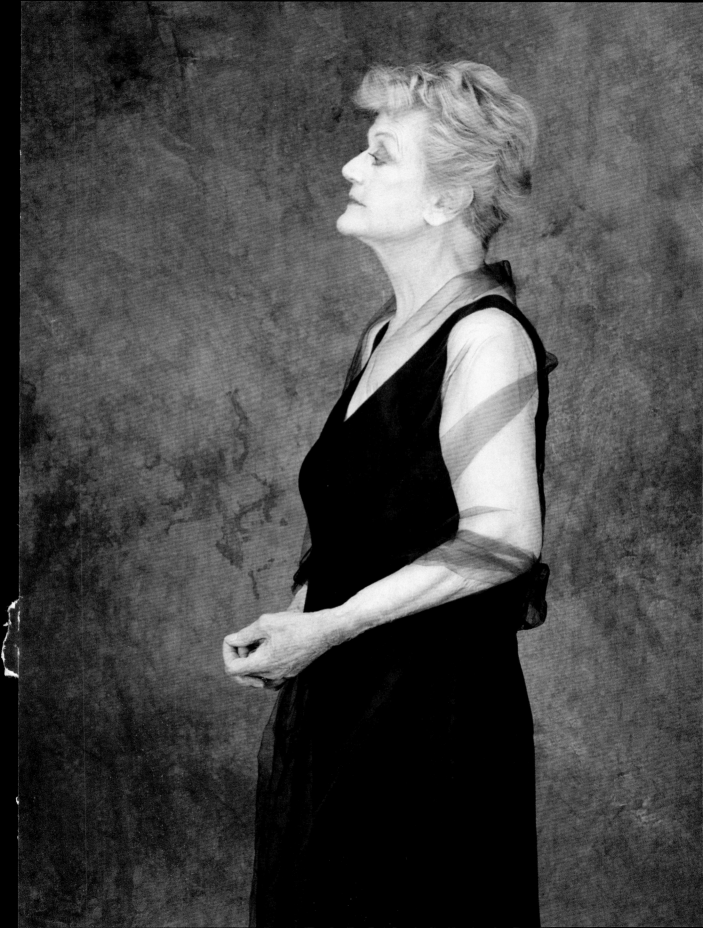

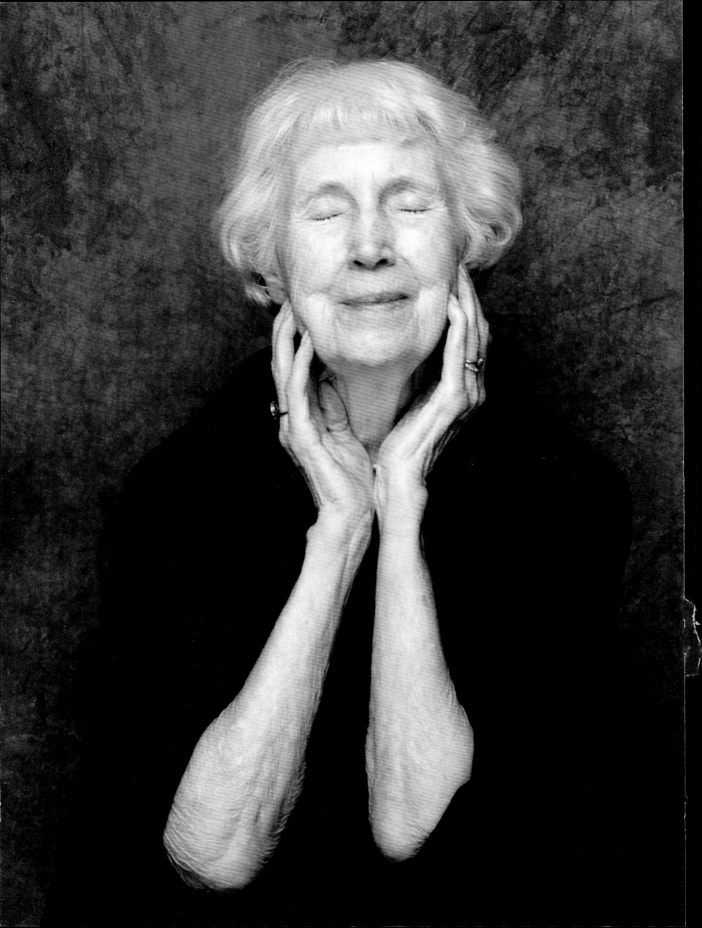

I can still remember

what it feels like

to love with all my heart.

Elva Azzara, 93

LIST OF PLATES

Frontispiece: Deirdre Sullivan; page 12: Zelda Kaplan; 15: Betty Silverstein; 16: Dr. Johnnetta Cole; 18, 19: Gloria Steinem; 20: Sophie Saleiman, Hannah Cohen, Natalie Cohen; 22: Lola Santos and Alex; 23: Lola Santos; 24: Maezie Murphy; 25: Evelyn Lauder; 27: Fay Gold; 28: Mona Miwako Lutz and China Chow; 30: Brooke Astor; 33: Patricia Neal; 34: Birdie M. Hale; 37: Dina Paisner; 38, 39: Marian Seldes; 41: Licia Albanese; 42: Marilyn Alex; 45: Gloria Larsen; 46: Helen Gurley Brown; 47: Nathalia Bowser; 48: Sadie Simms Allen; 51: Polly Kline; 52: Elaine Alexander; 53: Helen Brown and Nellie Andins; 55: Odetta; 56: Edith Turner and Ruth Turner; 59: Joanna Harris; 60: Madeline Burt and Ragna Solaas; 63: Sister Elise and Sister Mary Christabel; 64: Betsy Brown; 65: Jane Greenwood Edwards; 66: Christine Lee; 69: Aldona Laita; 70: Melissa Hayden; 71: Christine Neubert; 72: Andree Ruellan; 74: Lauren Bacall; 75: Cornelia Bessie; 77: Cicely Tyson; 78: Jan Owen; 81: Mary Hinkson Jackson; 82, 83: Jane Goodall; 84: Paula Laurence and Lily Tomlin; 85: Tammy Grimes; 87: Kitty Carlisle Hart; 88: Justice Sandra Day O'Connor; 91: Libby Lyman; 92: Ann Richards; 95: Ruth Handler; 96: Joan D'Arcy; 97: Annette Covino and Bernie; 98: Mathilde Krim; 101: Clara Holm; 102: Lenore Reichart and Helen Reichert; 104: Ann Sederocanellis and Stephanie Lienhard; 105: Lilo Raymond; 106, 107: Mimi Weddell; 108: Jeanie MacPherson; 111: Dolores Fleming; 112: Jessica Tandy; 114: Liz Smith; 115: Tippi Hedren; 116, 117: Dame Judi Dench; 118: Ann Cole and Fran Rappaport; 119: Phyllis Silverman; 121: Geraldine Smith; 122: Krista Gottlieb; 125: Kathleen Kenyon, Colleen Kenyon, Kathleen R. Kenyon; 126: Angelita Martinez and Constance Mirabal; 128, 129: Julie Harris; 131: Geraldine Ferraro; 132: Trisha Brown; 135: Ingerborg Ten Haeff; 136, 137: Coretta Scott King; 139: Angela Lansbury; 140: Elva Azzara

BEHIND THE SCENES

(candid photos taken at photo shoots around the country)

1. Joyce and Coretta Scott King in Atlanta, GA. ph. Terri Clark 2. Krista Gottlieb and Joyce, New York City. ph. Elin Hoyland 3. Elva Azzara in Sacramento, CA. ph. Sean Franzen 4. Joyce and Sisters Elise and Mary Christabel, New York City. ph. Lisa Devlin 5. Helen Brown, Nellie Andins, and Joyce, Atlanta, GA. ph Terri Clark 6. Joyce with Gloria Larsen, New York City. ph. Lisa Devlin 7. Elva Azzara in Sacramento, CA. ph. Sean Franzen 8. Gloria Steinem, New York City. ph. Lisa Devlin 9. Supreme Court Justice Sandra Day O'Connor and Joyce, Washington, D.C. ph. Frank Lavelle 10. Joyce and Coretta Scott King in Atlanta, GA. ph. Terri Clark 11. Joyce and Coretta Scott King in Atlanta, GA. ph. Terri Clark 12. Joyce and Cicely Tyson, New York City. ph. Miwa Nishio 13. Joyce and twins Fran Rappaport and Ann Cole, New York City. ph. Miwa Nishio 14. Joyce looking at family photos with Helen Brown, Atlanta, GA. ph. Terri Clark 15. Joyce and Sadie Simms Allen, Sacramento, CA. ph. Sean Franzen 16. New York studio team: Miwa Nishio, Michael Goesele, Lisa Devlin, and Joyce, with Christine Lee holding her cover image. ph. Henders Haggerty

ACKNOWLEDGMENTS

I would like to thank the many people who helped me through the complexities that surround a book project of this magnitude. Thank you in particular to Janet Bush, my always intelligent and supportive editor; to David Jones, my partner, who has helped make my prose more precise and my personal life more generous when it was under threat from deadlines and workaholic tendencies. Also, special thanks to Miwa Nishio, my top assistant, who has been with me throughout the entire project; to Michael Goesele, who designed the book with rare insight; and finally to my son, Alex, who continues to support and protect my more vulnerable inner nature.

I would also like to thank my many students who have helped me know the world better, and the countless friends and colleagues who have supported me over the years with their interest, critiques, and love. I have been blessed by others who have given generously of their time, helping with the many production aspects, scheduling, organizing, assisting, editing, and encouraging. To the following people my deepest gratitude:

Alison Bank, Dan Bereskin, Jami Broadbent, Reid Callanan, Eleanor Caponigro, Linda Chester, Terri Childs, Terri Clark, Kate Donovan Cohen, Marcy Cohen, Melinda Cornwell, Alex Cuesta, Kelly Cutrone, Caryn Davis, Lisa Devlin, Chris Dougherty, Anne and Jack Doyle, Wendy Dubit, Beth Filler, Ben Fraser, Linda Freeman, Bonnie Fuller, Celia Fuller, Suzanne Goldstein, Veronique Guillem, Tom Halsted, Wendy Hunter, Sandra Klimt, Bronwen Latimer, Frank Lavelle, Stephanie Leinhard, Laura Lindgren, Sarah Long, David Lyman, Donna Marciano, Meredith Marlay, Dave Metz, Don Mitchell, Sally Nelson, Stephen Nelson, Mike Newler, Liz Ogilvie, Kathleen Pratnicki, Judith Puckett, John Reuter, Loretta Roome, Sarah Rozen, Gonzalo Rufatt, Kathy Ryan, Kristin Sabena, Craig Sanders, Sao, Denise Sfraga, Dan Steinhardt, Michele Stephenson, Barbara Cardamone Thies, Amy Wellnitz, Elise Wiarda.

Finally, I'd like to pay tribute to my Celtic ancestors, who through their traditions of directness, strength, hypnotic storytelling, and openness to the unseen realms, have helped me find my own voice and destiny.